MOTION **DESIGN**

RotoVision

A RotoVision Book
Published and distributed by RotoVision SA
Route Suisse 9
CH-1295 Mies
Switzerland

RotoVision SA
Sales & Editorial Office
Sheridan House, 112/116A Western Road
Hove BN3 1DD, UK

Tel: +44 (0)1273 72 72 68
Fax: +44 (0)1273 72 72 69
Email: sales@rotovision.com
Web: www.rotovision.com

10 9 8 7 6 5 4 3 2 1

ISBN: 2-88046-789-6

Reprographics in Singapore by
ProVision Pte. Ltd

Tel: +65 6334 7720
Fax: +65 6334 7721

Printed in China

Book design and illustration
Matt Woolman and PLAID Studios

Art direction
Luke Herriott

Motion-graphics illustrations and sequences
Jeff Bellantoni and John Stanko

Text © 2004 Matt Woolman and
Jeff Bellantoni

Inquiries:
Email: info@plaidstudios.com
Web: www.plaidstudios.com

Although every effort has been made to
contact the owners of the copyright material
that is produced in this book, we have not
always been successful. In the event of a
copyright query, please contact the publisher.

MOTION **DESIGN**

Moving
Graphics for Television,
Music Video,
Cinema, and Digital Interfaces

Matt Woolman

WWW.ORBITFINDER.COM/MOTIONDESIGN

Motion Design is both a book and a Web site. The book is intended as a field manual: part design exhibition, part inspirational resource for ideas, part reference for the fundamentals of process and technology behind motion design. Ideally, the fundamentals will not change over time, but technology and its creative uses will.

The Web site is a catalog of many of the motion-graphics works—fundamental examples, student and professional projects—presented in the book, made available for viewing in real time. These works are numbered according to the sequence number and page number of their appearance in the book, for example:

000 I 000 PROJECT TITLE

SEQUENCE **PAGE**

Table of Contents

Designing for Motion

All pictorial form begins with the point that sets itself in motion... The point moves ... and the line comes into being—the first dimension. If the line shifts to form a plane, we obtain a two-dimensional element. In the movement from plane to spaces, the clash of planes gives rise to body (three-dimensional)... A summary of the kinetic energies which move the point into a line, the line into a plane, and the plane into a spatial dimension. (Paul Klee)

WHAT IS MOTION DESIGN?

The desktop computer has transformed the design profession profoundly over the past 25 years. Distinct stages of evolution are marked by points at which the once quaint profession of commercial art, or graphic design, has grown into something more complex, as the designer has expanded into new skill sets and areas of creative practice. The eighties saw many print production processes, such as page layout, typesetting, and mechanical preparation, move from the domain of specialists working in these areas and onto the desktop of the designer's workspace. In the early nineties, an explosion of typeface design was the result of consumer access to technology: PostScript language and software for creating and modifying typefaces reached the designer's hands. By the mid-nineties, the designer gained access to the tools for creating and producing Web sites and moving type. We are now in the midst of a new wave commonly referred to as *motion graphics*, or *motion design.*

Behind this new wave lies yet another technological evolution. Design studios now have access to highly advanced yet affordable hardware and software literally on their desktops. Both 2-D and 3-D animation and video production are now possible "in-house," rather than in specialized—and expensive—shops. The tools of the trade include digital and film still and motion cameras with software such as SOFTIMAGE XSI, Flame/Combustion by Discreet, Maya by Alias/Wavefront, Adobe Illustrator, Photoshop, and After Effects. File formats such as MPEG3 and MPEG4, QuickTime, and others allow for efficient editing, production, and delivery of finished sequences.

Motion-graphics design is not a single discipline. It is a convergence of animation, illustration, graphic design, narrative filmmaking, sculpture, and architecture, to name only a few. The word "graphic" is important: this includes formal content that has a graphic emphasis such as symbols, icons, and illustrated 2- and 3-D objects, often synthesized with live action.

With *Moving Type: Designing for Time and Space*, Jeff Bellantoni and I began the discourse on the fundamentals of typography in time-based environments, be it animated, interactive, or both. We compiled and developed these fundamentals from a combination of other source points: the principles of typographic design, and the principles of time-based media such as film and animation. *Motion Design: Moving Graphics for Television, Music Video, Cinema, and Digital Interfaces* builds upon this foundation. Many of the important aspects featured in *Moving Type* have been incorporated into, and expanded within, *Motion Design.*

The premise of *Motion Design* is rooted in Paul Klee's notion of point, line, and plane. The first part of the book is divided into three sections, each presenting a fundamental component of motion design: space, form, and time. Rich with diagrams, illustrations, and verbal explanations, these components relate closely to our understanding of actors and their interaction on the stage. One element moving in a screen space is like an actor alone on the stage. Two elements on a stage allow for interaction to take place, and the possibility for a story to emerge. The stage itself can be a barren space, or can be a rich synthesis of a live-action cityscape with illustrated embellishments.

A section on design process features selected projects from university programs on the cutting edge of motion-graphics education and training. In addition to student projects and solutions, this section presents thoughts by instructors and students, along with project briefs that outline specific learning objectives. This section reveals one secret of this book, and the entire discipline of motion design—it is not all about the computer. The successful outcome of any project is not the idea, but the *process* behind the realization of that idea. Image-making can be exercised in many ways, on- and offline.

Professional Profiles features a vital selection of motion-graphics design studios, emphasizing their unique approach and style. The featured projects are no more than one minute in length. These works have the function of television commercials, program and film identities, titles, bumpers, and teasers. The occasional music video is the only format that breaks the one-minute criterion.

This section reveals another secret of this book and of motion design—rarely is a motion-graphics product the result of a single creative individual. Even though the hardware and software tools have become democratized, motion graphics is a convergence of many separate disciplines—teamwork is highly important.

Motion Design is not a technical "how-to" manual; computer hardware and software are just a means to an end. *Motion Design* is a point of departure for further investigation. There are many summaries in these pages that can spark further investigation into areas of animation, typography, filmmaking, and sound design. Like *Moving Type*, the intention of *Motion Design*, and its accompanying Web site, is to provide a source for motion design years into its evolution.

The fundamentals of space, form, and time were developed as a means of teaching design for motion in relation to appropriate, creative, and effective visual communication. They build upon the fundamental principles underlying good design that, alone, cannot adequately address design for motion.

The sections Space, Form, and Time correspond with the morphology presented on the next two pages. The motion examples in these sections are intentionally simple in order to demonstrate specific fundamentals effectively. The fundamentals do not address specific media such as film or broadcast, but are intended instead to function as a foundation upon which the designer can build his or her understanding of design for motion, in order to apply it to whatever medium they find themselves working in.

Separating Space, Form, and Time are five technology sections that provide specific information and terminology concerned with design processes, methodologies, and production considerations regarding graphics for motion: Animation, Media, Semiotics, Color, and Preproduction.

WHAT IS A MORPHOLOGY?

A morphology is the study of the structure and form of a language system, including inflection, derivation, and the formation of compounds. In this book, a morphology is presented for the study of the language of motion-graphics design.

Morphologies are tools that can be used in the process of creating and analyzing. The beauty of the morphology is its flexibility. It should be considered a source of specific attributes and variables, but also as a framework within which to improvise, experiment, and invent.

The morphology on the facing page is purposely a morphology for motion design. Presented in a matrix format, this morphology draws upon the thinking of design educators Kenneth Hiebert and Rob Carter. The morphology in this book has three parts, which coincide with the three primary considerations behind motion design: space, form, and time. Space includes attributes related to the space—or stage—in which a motion sequence operates. Form includes any and all visual elements—or actors—that perform in the stage space. Time is the critical consideration of motion design, and includes attributes that describe events occurring over a period of transformations, stages, frames, space, and so on.

The functioning components of the morphology are its various attributes and variables. The morphology in this book presents attributes—or characteristics—in lists under each category, within each of the three parts. For example, 1 SPACE has two categories: 1.1 STRUCTURE and 1.2 FRAME. Each of these two categories has a list of attributes: 1.1 STRUCTURE has 1.1.1 elements and 1.1.2 perspective. Generally, the variables cover a spectrum of possibilities for each attribute. Some describe a range, others are distinct opposites. Hiebert describes this as a contrast continuum. Roland Barthes used the term "binary opposition." It is a way of thinking not only about design, but about life. For example, considering the human attribute of "feeling," we do not really understand the variable of "happy" until we understand "sad." Applied to design, we can consider syntactic (visual) attributes such as a shape varying from geometric (a square) to organic (a tree leaf).

The following sections in this book—Space, Form, Time—present examples of each of the attributes and variables in this morphology. Several student projects presented in Design Process also illustrate the morphology in use.

1 Space

1.1 STRUCTURE

1.1.1 elements	point	line	plane	volume
1.1.2 perspective	one-point	two-point	three-point	multiple

1.2 FRAME

1.2.1 aspect ratio	1.33:1 (4:3)	1.66:1	1.85:1 (16:9)	custom
1.2.2 orientation	horizontal	vertical		
1.2.3 composition	room	window	single	multiple
1.2.4 ground	planar	linear		
1.2.5 depth	scale	focus	shallow	deep
1.2.6 mask	geometric	organic		

2 Form

2.1 IMAGE

2.1.1 render	graphic	photographic	drawn	
2.1.2 shape	geometric	organic	hybrid	
2.1.3 size	small	medium	large	
2.1.4 color	monochromatic	polychromatic	solid	gradient
2.1.5 surface	outlined	shaded	textured	patterned
2.1.6 dimensionality	flat	extruded	shadowed	simulated

2.2 TEXT

2.2.1 case	upper	combination	lower	
2.2.2 face	geometric	hybrid	humanist	
2.2.3 size	small	medium	large	
2.2.4 weight	light	medium	heavy	
2.2.5 width	condensed	medium	wide	
2.2.6 posture	roman	italic	oblique	custom

2.3 SUPPORTING

2.3.1 line	straight	curved	uniform	variable
2.3.2 symbol	alphabetic	analphabetic	numeric	pictorial
2.3.3 shape	geometric	organic	hybrid	
2.3.4 audio	voice	music	sound	ambient

3 Time

3.1 MOTION

3.1.1 dynamics	real time	implied	abstract	
3.1.2 direction	straight	curved	spatial	
3.1.3 orientation	upright	inverted	radial	skewed
3.1.4 rotation	flat	spatial	random	
3.1.5 proximity	spatial	sequential		
3.1.6 grouping	symmetrical	asymmetrical	consonant	dissonant
3.1.7 layering	opaque	translucent	transparent	
3.1.8 transformation	reductive	elaborative	distortive	

3.2 SEQUENCE

3.2.1 structure	linear	nonlinear		
3.2.2 juxtaposition	layered	sequential	simultaneous	
3.2.3 hierarchy	image	text	audio	synthesis
3.2.4 transition	cut	wipe	fade	dissolve
3.2.5 rhythm	repeating	alternating	synchronous	asynchronous
3.2.6 duration and pause	foreshadow	recall		

Animation

Vivacity, passion, the state of being alive—these are some of the definitions that the *Concise Oxford English Dictionary* attributes to animation. Less exciting but more precisely, animation is the stasis-to-motion technique of creating the illusion of movement through recording successive stills to be shown sequentially.

Persistence of vision is the physiological phenomenon that explains how we perceive motion through the animation of still images or words. Our mind's eye holds onto the images for a slightly longer duration than they are actually "seen" by the retina, so that a series of quick flashes is perceived as one continuous image. This is the perceptual foundation of all sequential media.

MOTION PATH AND FRAME RATE

A simple animation involves an object moving through space. This movement can be defined along a linear "motion path." The two primary components are the type of path that the object follows, and the rate, in terms of the number of frames, at which the object moves along this path.

Producing an animation by hand is extraordinarily time-consuming. A two-minute animation at 24fps (frames per second) would consist of 2,880 individual drawings, with one drawing for each frame: 24 (frames) x 120 (seconds) = 2,880. Animators save time by duplicating drawings over a two- or three-frame duration. In other words, each drawing would be exposed onto film or video for two or three consecutive frames. This is known as the frame rate of the animation (working on 2s, or 3s). If the 2,880-frame animation was "shot on 3s," then only 960 individual drawings would be needed. This is still extremely time-consuming, but less so than otherwise.

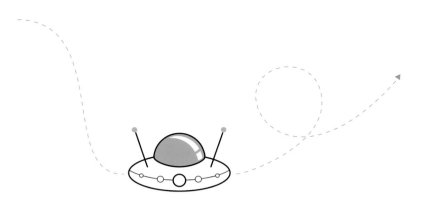

KEY FRAMES AND IN-BETWEENING

Key frames are the specific frames that designate the beginning and end of a movement or direction, opacity, scale, or other change in the nature of the activity. The frames that exist, or fill in, between key frames are known as in-betweens. Digital-animation software will complete an action by filling in the in-betweens once the key frames have been designated. The 24 frames below illustrate the full 1-second animation with key frames and in-betweens.

A flying saucer is animated horizontally from the left side of the frame to the right. The action will occur over a period of 1 second. It is placed at the starting position of the movement, at which point a key frame is designated. Moving forward in the timeline by 1 second, a second key frame is designated. Software applications such as Macromedia Flash will fill in the positions of the flying saucer across this path. Multiple key frames can exist in a single sequence, as illustrated by the running figure opposite.

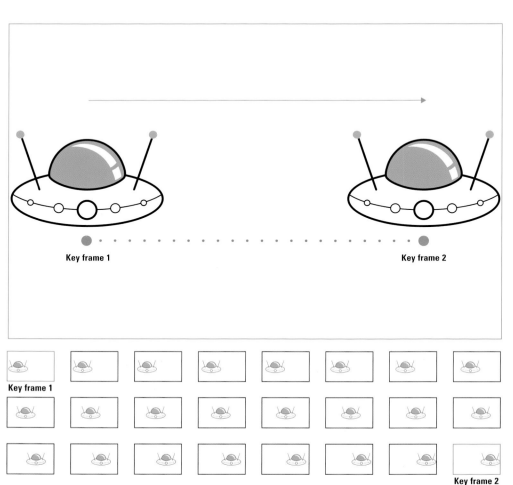

Key frame 1

Key frame 2

Key frame 1

Key frame 2

A 1-second (24-frame) sequence of a flying saucer moving from left to right in a viewing frame

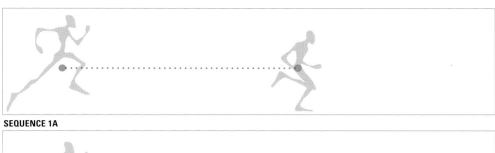

No easing in/out as saucer moves from top to bottom

Easing in from top, and out at bottom

Hovering: easing in slowly at top, and quickly at bottom

SPEED AND SMOOTHNESS

Both the duration and the number of frames an action requires, and the distance a movement has to traverse in the frame, affect the speed and smoothness of animation. Assuming a constant distance, the greater the number of frames it takes to travel that distance, the longer the duration of the movement—slower and smoother. The fewer the number of frames the movement takes to travel that distance, the shorter the duration—faster and coarser.

Assuming a constant duration and number of frames, the greater the distance an object has to travel, the faster it will move; the shorter the distance an object has to travel, the slower it will move.

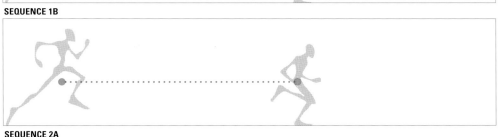

SEQUENCE 1A

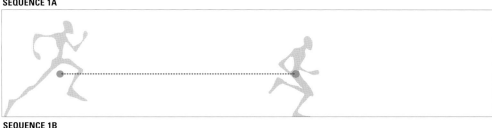

SEQUENCE 1B

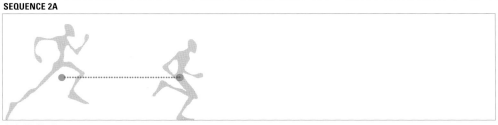

SEQUENCE 2A

SEQUENCE 2B

EASING IN/EASING OUT

The steady transition from stasis to a constant speed is known as easing in and easing out. An automobile does not speed up or stop instantly, the change is gradual. Easing in and out adjusts the speed at the beginning and ending of a movement—the key frames—to enhance the reality of the movement, create a particular effect, or allow a smoother motion for the path.

The first sequence above left demonstrates a path with no easing in or out; the speed of the path is constant. The flying saucer then follows the path with easing in and out illustrated. The motion is much more fluid and smooth. Finally, the flying saucer begins to hover, demonstrating how easing in and out can support reality, with the flying saucer counteracting gravitational pull.

CONSTANT DISTANCE: Based on 30fps, sequence 1 travels at a constant 316 pixels' distance horizontally across the frame. 1A is set for a 45-frame duration, so the path is completed in 1.5 seconds. 1B is set for a 90-frame duration, so the path is completed in 3 seconds. The same distance covered with more frames will give a longer duration.

CONSTANT DURATION AND FRAME COUNT: Sequence 2, also based on 30fps, travels at a constant duration of 1.5 seconds. 2A is set for a distance of 316 pixels, and takes 45 frames to complete the path. 2B is set for a distance of 162 pixels, half that of the first distance. It still takes only 45 frames to complete the path, but appears to move more slowly. The same duration used to cover less distance will give the appearance of slower movement.

Animation

Historically, animated films were hand-drawn and then photographed frame by frame onto film and, later, videotape. This technique is still employed today, with digital technology used to assist in the process, as opposed to animation that is completely digital, as for Disney's *Finding Nemo*.

A number of techniques and materials used in traditional animation processes are illustrated here. All of these analog techniques are still viable today, and many have become married to digital technology to reduce the time they require and to ease the labor process.

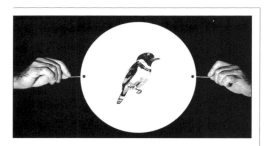

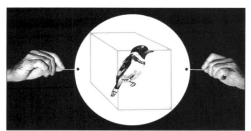

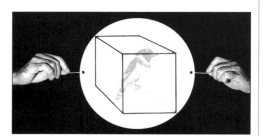

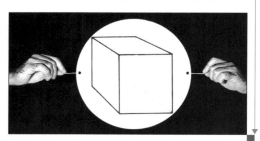

FLIP BOOK

One of the earliest animation techniques, a flip book is a small book consisting of a series of images on individual pages that give the illusion of continuous movement when the edges of the pages are flipped quickly. This also demonstrates persistence of vision.

THAUMATROPE

The thaumatrope, a toy that was widely available in the nineteenth century, demonstrates persistence of vision. A disc is suspended between two strings; when spun, images placed on either side of the disc are perceived as one.

CAMERALESS ANIMATION

Cameraless animations, also known as scratch films, involve working directly on the film celluloid, such as 16mm-film clear leader or black leader. Clear leader allows the animator to draw directly onto the film; the marks on the film block the light from the projector. Black leader, which has a black coating on the celluloid intended to block the light of the projector, can be scratched away to allow the light through, thereby creating white lines and marks when projected. In addition to being scratched away, black leader can be dissolved with household bleach, or have colors applied, holes punched, etc. Beautiful and extremely kinetic visual activity can be accomplished in cameraless animation when the frame lines of the film strip are ignored.

LINE-AND-CELL ANIMATION

One of the most well-known but time-consuming methods of animation is line-and-cell animation. This technique involves drawing directly on paper or transparent sheets of celluloid, frame by frame. Each drawing, or cell, is then photographed onto film or videotape, or digitally scanned.

STOP-MOTION ANIMATION

Stop-motion animation is also a frame-by-frame technique, but it involves animating objects rather than drawings. Processes such as claymation and puppet animation are examples of the stop-motion technique. Slight changes in the object's position are captured onto film, videotape, or a computer, frame by frame.

ROTOSCOPING

In rotoscoping, the image on each frame is directly traced or manipulated. Digital rotoscoping has made easier what was once a technique that involved complicated and expensive analog equipment.

SPACE

This section presents the first of three fundamental categories of motion-graphics design: space. It is beneficial to consider the space of the screen—be it television, computer, cinema, or even mobile telephone—as architectural rather than strictly compositional.

Space discusses the subject in two parts: structure and frame. Each of these essential components has its own set of attributes. Structure covers the elements that define space—point, line, plane, and volume—and the element that renders dimension—perspective. Frame addresses aspect ratios of screens, frame orientation, and composition, and the internal aspects of ground, depth, and mask.

SPACE

Structure · elements

POINT
LINE
PLANE
VOLUME

The principles of 3-D design are important to time-based media. There are four conceptually driven elements of space that it is beneficial for the graphic designer to have a clear understanding of when designing for the screen: point, line, plane, and volume. There is every reason for a designer who works in time-based media to have an understanding of space beyond the 2-D surface. The screen may confine moving objects to a defined flat surface, but the perception of space exists nonetheless.

Because we live in a 3-D world, we can perceive the concept of space quite easily and, in many ways, better than that of a flat, 2-D surface. It is this perception that differentiates thinking sculpturally from thinking pictorially.

POINT

A point indicates a position in space and occurs at each end of a single line. A point can also be found where lines intersect, and where lines meet at the corner of a plane.

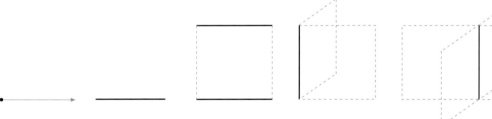

LINE

As a point moves, its path maps out a line. A line is defined by at least two points in space. A line has position and direction, defines the edge of a plane, and exists where two planes intersect or join.

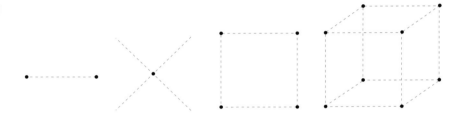

PLANE

As a line moves in a direction other than its own inherent direction, its path maps out a plane. A plane is defined by at least one line. A plane, bound by lines, defines the external limits of a volume.

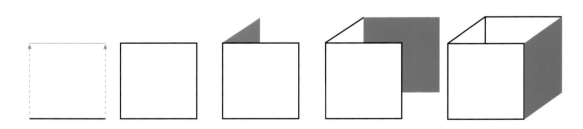

VOLUME

As a plane moves in a direction other than its own inherent direction, its path maps out a volume. Volume defines the space contained within it or displaced by it.

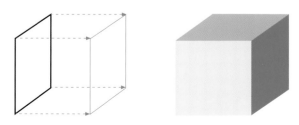

Structure · perspective

ONE-POINT
TWO-POINT
THREE-POINT

Geometric or linear perspective was developed by three artists working in the early Renaissance (fifteenth-century Italy): Masaccio, a painter; Donatello, a sculptor; and Brunelleschi, originally a painter and later an architect. The system is based on converging parallels. It employs a horizon line, which divides the picture plane into ground plane and sky plane (much like looking out the window of a house), and a vanishing point, the point at which the parallels converge.

Traditional drawing uses a system based on the geometry of converging parallels to create the illusion of 3-D objects on the 2-D surface of the picture plane, known as one-, two-, or three-point perspective. The establishment of a foreground and background is created through value, contrast, scale, and color variations between objects, and enhances the manipulation of space.

ONE-POINT

One-point perspective is used to render an object as though one face is parallel with the picture plane. One-point perspective is achieved through repetition and reduction in scale, and utilizes a single vanishing point.

TWO-POINT

Two-point perspective is used to make an object appear to be at an angle to the lines of sight, or at an angular position in depth on the picture plane. Two-point perspective utilizes two vanishing points.

THREE-POINT

Three-point perspective, consisting of a third point above eye level, is used to illustrate a tall object that recedes upward in space, like a skyscraper, or to give a view down along an object that appears to become smaller as it recedes below the eye level of the observer. Three-point perspective utilizes three vanishing points.

SPACE

Frame · aspect ratio

1.33:1 (4:3)
1.66:1
1.85:1 (16:9)

The active composition space in relation to the screen is known as the frame. In film, the frame refers to both the image on the film and the dimensions of the projected screen; in video, it refers to the video monitor itself; and in digital media, the frame refers to the boundary that confines the sequence.

The frame aspect ratio is the ratio between the width and the height of the frame. Three common frame aspect ratios are 1.33:1, or 4:3; 1.66:1; and 1.85:1, or 16:9. These ratios were originally developed to accommodate camera and film stock limitations. Because of these technological limitations, the designer was formerly restricted to working within one of these frame aspect ratios. Film, which allows a wider aspect ratio, imitates the way we see the world most closely.

FRAME ASPECT RATIOS

1.33:1 (4:3)

standard television

1.66:1

film

1.85:1 (16:9)

HDTV (high-density television),
anamorphic DVD (digital video disc),
wide DV (digital video)

Frame · orientation

HORIZONTALLY EXTENDED
VERTICALLY EXTENDED

Frame aspect ratios should be carefully considered with regard to production and display technologies as well as content. A horizontal aspect ratio can be used to emphasize distance because we see a horizontal rectangle as a landscape. A vertically oriented sequence can support the concept of height or falling.

HORIZONTALLY EXTENDED

VERTICALLY EXTENDED

Frame · composition

AS ROOM

AS WINDOW

The frame is the plane through which the audience views the action. One way to compose elements within the space of the viewing frame is to utilize the Cartesian coordinate system, which is defined by a set of mutually perpendicular axes. An axis is an imaginary straight line that defines the center of a body or geometric object, and is the line around which this object may rotate.

The x-axis is horizontal, the y-axis is vertical, and the z-axis is spatial. We can further describe the space as having three planes of composition: frame, depth, and geographic. Composing the frame in this manner follows the way in which a filmmaker views a scene through the lens of a camera.

SYSTEMS OF DESCRIBING SPACE IN A FRAME

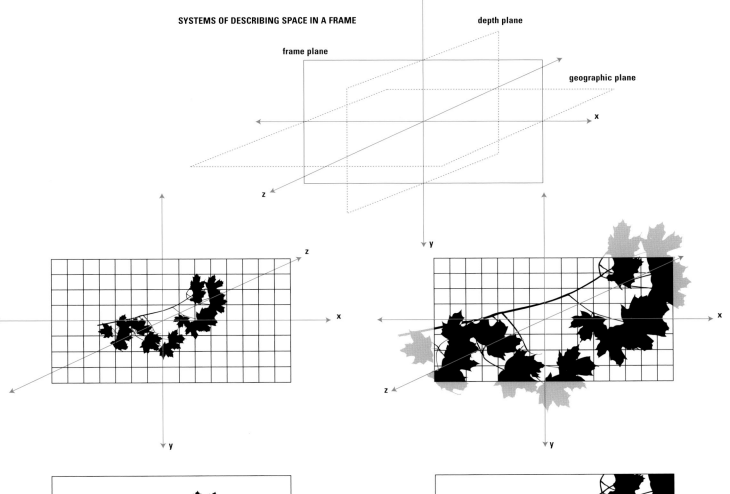

AS ROOM

A frame can serve as a room that contains elements. Here, the borders are perceived as solid walls. In a similar situation as furniture in a bedroom, the elements are contained in the active space and have nowhere to move but within its borders.

AS WINDOW

A frame can also serve as a window that looks out into a larger space. The borders capture elements—in part or whole—as they move through this space. Only those elements captured within the borders are seen by the viewer, but the viewer senses a larger realm of activity beyond the borders.

Frame · ground

PLANAR GROUND
LINEAR GROUND

Ground can be categorized as planar or linear. Planar ground refers to the relationship between the background plane and the object in the foreground. This is often referred to as the figure–ground relationship. The contrast levels of color, hue, and value help establish a foreground and background. The greater the contrast between the object and its ground, the more the ground will appear to recede and the object appear to advance.

Linear ground refers to the position of the object in relation to the viewer, based on an assumed camera angle—as though the object is being viewed through a camera. In cinematic terms, the linear ground—often called the horizontal plane—refers to the typical way in which humans see everything level. A filmmaker can turn the camera in such a way as to alter the linear ground, which creates a tension between the viewer and the film image.

001 | 020

002 | 020

PLANAR GROUND

Altering the planar ground over time produces an optical effect of advancing and receding objects, even though the elements do not change in scale.

LINEAR GROUND

Altering the linear ground in a graphic sequence creates a tension between the viewer and the image. The horizontal plane can be level, tilted, or altered over time. Combining an increasing scale change with a tilted horizontal plane can produce the effect of moving or flying.

Frame · depth

SCALE SHIFT
VALUE SHIFT
SHALLOW AND DEEP FOCUS

A sense of depth can be enhanced by contrasts in the tonality and value of the objects. No longer limited to small versus large, altering tonality and value over time creates a hierarchy based on advancing versus receding objects.

The distance between the farthest and nearest points that appear sharp (in focus) through the lens of a camera is called the depth of field. Controlling depth of field, an important aspect of photography and filmmaking, also becomes an integral factor for the establishment of depth within the frame.

003 | 021

004 | 021

005 | 021

SCALE SHIFT

Scale is the most obvious determinant of depth; the larger the object appears in relationship to the frame, the closer it will appear to the viewer. Conversely, a smaller object will appear farther away.

VALUE SHIFT

A shift in the value range of one object in relation to another can convey a sense of depth within the viewing frame.

SHALLOW AND DEEP FOCUS

With shallow focus, the object in the foreground (closest to the lens of the camera or the frame of the animation) is in focus, while the object in the background (farthest from the lens of the camera or the frame of the animation) is out of focus. With deep focus, the object appearing in the foreground is out of focus, while the object in the background is in focus.

Frame · mask

GEOMETRIC
ORGANIC

Masking alters the rectangular-frame boundaries perceptually. Masks allow the designer to simulate a nonrectangular geometric frame, or even an organic frame.

This effect can be further enhanced if the color of the computer monitor's desktop is the same as the masked areas of the frame.

GEOMETRIC

ORGANIC

ORGANIC MASK MATCHING MONITOR SCREEN

Media

The medium is the means by which something is communicated; its physical makeup—paint on a canvas, print on a page, videotape, film, and binary code on a disc, for example. Media are classified according to format—either analog or digital.

The context in which a particular medium exists also defines it: paintings hang in a museum or gallery, printed pages are bound into a book, video signals are broadcast over television, films are projected in theaters, binary code makes up the Web sites that exist on the Internet. Then there is the process involved; the act that occurs. You can paint something, typeset it, animate it, or film it.

However, a problem exists in attempting to differentiate the various media in their various contexts because most also exist in digital form. Digital video is binary code recorded on a magnetic videotape. The image seen on the video screen is binary code transformed into a video signal. This same digital video signal can be seen on the Web site itself, no longer needing videotape at all.

Film is experiencing the same confusion. The addition of the word "digital" to these traditionally analog terms adds to the confusion: digital film, digital video, digital animation, digital imaging, and so on. Digital video/film/etc. is an oxymoron.

ANALOG VERSUS DIGITAL

Analog media consist of signals or information represented by a continuously variable quantity, and capable of smooth fluctuations. An electric current, waves of water, light, sound, and most everything in nature is analog. A vinyl record is an analog medium in that a turntable needle must make contact with the tiny grooves on the record's surface in order to reproduce the sound.

Digital media consist of signals or information represented by digits or numbers, and processed by a computer. Value differences exist in discrete steps, as opposed to smooth fluctuations. Most modern electronics are digital. A compact disc is a digital medium in that a light beam reads—without any physical contact—the variable-length dashes embedded on the surface in order to reproduce sound and/or image information stored on the disc.

Digital media are superior to analog media in several ways. Analog media degrade when copied—a process known as generation loss. Digital media are not subject to generation loss, and can be manipulated a great deal without leading to any reduction in their quality. In addition, digital media can be used in conjunction with other media, yet retain their own properties. For example, a digital video signal can be recorded on multiple analog magnetic tapes without any loss, because it originates from a digital source.

COMPACT DISC: DIGITAL MEDIUM

VINYL RECORD: ANALOG MEDIUM

BINARY CODING SYSTEM

Like the human brain, the computer consists of millions of tiny interconnected circuits and switches that need to be moved into a position that forms a closed path before anything can happen.

The computer's method of thinking, or "coding," is known as a binary system, meaning "duals" or "pairs." For example, instructions are received in the form of opposites:

on or off

positive or negative

something or nothing

light or dark

yes or no

The computer does not understand the above words as humans understand them. In order for the computer to understand a specific command, it must be translated into binary digits, or "bits."

Bits are represented in the form of 0s and 1s. This correlates with the power switches on many electrical appliances.

1 = positive = ON

0 = negative = OFF

TWO BASIC COMMANDS: A single 0 or 1 means nothing to the computer, just like single letters of the alphabet mean nothing to humans until they are strung together into words.

A string of at least two bits is needed to form anything meaningful to the computer. Two bits can form four different instructions, for example, to illuminate a pixel in one of four shades of black.

01000001 = A
01100001 = a
01000010 = B
01100010 = b
00110001 = 1
...

KEYBOARD CHARACTERS: All characters of the computer keyboard—upper/lowercase letters, numerals, punctuation marks, and other symbols—must be represented by binary code. Each character is represented by an 8-bit code.

The maximum number of different configurations that eight 1s and 0s can make is 256. There are 256 places for characters built into the computer keyboard. Some human languages require more than this, but 256 is the standard.

EACH BIT VALUE IS DOUBLE THE PREVIOUS IN THE SERIES

1, 2, 4, 8, 16, 32, 64, 128, 256, 512, 1,024 ...

COMMONLY USED BINARY INCREMENTS

8 bits = 1 byte
1,024 bytes = 1 kilobyte (K)
1,024 kilobytes = 1 megabyte (Mb)
1,024 megabytes = 1 gigabyte (Gb)
1,024 gigabytes = 1 terabyte

BITS AND BYTES

The binary coding system is the primary system the computer uses to measure memory, color, and storage. This system involves pairs of numbers; each value is double the previous, beginning with 1. Together, 8 bits equal 1 byte, which is short for "binary term." Other measures are formed in increments of roughly one thousand.

BITMAP MATRIX

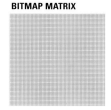

PIXELS AND BITMAPS

It is extremely important to understand issues of resolution for designing motion graphics. The convergent nature of the medium allows elements originated in any format to be incorporated into a motion-graphics sequence.

In order to render an image for display on a computer monitor, it must be rasterized, or converted into tiny dots known as pixels, short for "picture elements." This process takes place on a bitmap matrix that contains 72 pixels per inch (ppi), which is the average device resolution of a computer monitor. The pixel is the smallest visible element displayed on the computer monitor.

The display resolution refers to the number of pixels in a horizontal scanline multiplied by the number of scanlines. A display that is 640 x 480 has 640 pixels across each of the 480 lines, making a total of 307,200 pixels.

BITMAP IMAGES

Technically known as raster, this mode of representation uses pixels mapped onto a matrix to define the image. Each pixel is assigned a place and color value on the bitmap. Bitmap images are resolution-dependent, as the number of pixels used to define the image determines the image quality.

VECTOR IMAGES

This mode of representation uses lines, curves, and fills to define images: vectors describe the outline of an object mathematically according to its geometric characteristics. The computer uses the language known as PostScript to describe image information for printing. Vector images are resolution-independent and can be resized without any loss of image quality.

Media

IMAGE FILE FORMATS
DISPLAY RESOLUTION
FIELD DOMINANCE
STANDARD VS. HIGH-DEFINITION VIDEO
ASPECT RATIO
FRAME SIZE VS. PIXEL ASPECT RATIO
TITLE- AND ACTION-SAFE
SEQUENCE EDITING
TIME CODE

Context is important because, for example, designing a sequence for the cinema is quite different from designing one for a Web site—the experience of the audience in the cinema is not the same as that of someone sitting at a computer in an office or at home. Film relies on the phenomenon known as suspension of disbelief, the psychological element that gives a film its reality. When people sit in a theater and view a film, they suspend reality and accept what is happening before them as a real experience occurring at that moment; they share the same spatial and temporal continuums as the image on the screen.

The dark atmosphere of the theater and the scale of the screen, which is larger than life, are elements that allow for suspension of disbelief to occur. The environment and physical limitations of the computer, as well as the existence of an interface, and interaction by the audience, eliminates suspension of disbelief.

When designing for time and space, the question of medium (in what medium will the sequence be seen?) and context (where will the sequence be seen?) must be answered before any other decision can be made.

IMAGE FILE FORMATS

Motion-graphics sequences can include static images such as illustrations, freeze-frames, titles, and other text; stock images; vector and other graphics. The primary function of the various file formats is portability between different computer applications. Each file format has specific characteristics.

PICT 1: Original Macintosh picture format. This is Apple's standard file format and is supported by automatic compression and decompression in QuickTime. It is most commonly used in multimedia. It is limited to 8 bits or 256 colors (indexed colors) or grayscale.

PICT 2: Developed for storing 4- to 24-bit color images. It may not maintain the resolution of an image when scaled.

TIFF: Tagged Image File Format. This format has been adopted by the American National Standards Institute (ANSI) and International Standards Organization (ISO). It is the most common format. It creates high-resolution images of digital pages by converting vectored images into bits. It can save in color depths from dithered black-and-white to CMYK and RGB information in millions of colors and one form of compression. TIFF files are large in size but can be compressed easily without losing image quality.

TGA: Targa file format. This is an uncompressed file format that can store an image with millions of colors. It is supported by almost every computer platform and media application.

JPEG: Joint Photographic Experts Group. Both a compression method and a file format, this is a popular format due to its ability to compress to a very small size for transport, up to about one-tenth of the original size. The format supports grayscale and color information as well as variable size compressions. JPEG is a "lossy" format: it trades some image information (i.e. quality) for hefty compression ability, which makes it best for screen display—Web sites, motion graphics, etc.—rather than for printing.

GIF: Graphics Interchange Format. This was originally developed by CompuServe for sending compressed images over telephone lines. This format is best suited for Web site use: the file size is extremely small due to a color palette that is limited to a fixed number of colors. GIF files are usually saved at a resolution of 72dpi. This file format is not suitable for printing.

EPS: Encapsulated PostScript. This format can be saved in either ASCII or binary subformats. This is the most versatile format available as it allows both vector (line) and raster (bitmap) image information to be stored in a single file. It can embed halftones: an application can set the frequency and shape of the halftone dot and overrides similar settings in the printer's processor. It can also embed transfers. It allows tonal adjustments when printing without affecting the original values in the image itself.

ASCII: Text-based description of an image, which contains two versions of it, one for printing on a PostScript device, regardless of resolution, and the other a low-resolution bitmap version for display. It often cannot be edited.

BINARY: Similar to ASCII but uses numbers rather than text to store data. This is a good format for converting TIFF files for color separation. It offers smaller file sizes than ASCII EPS. This is the most versatile format and has many options. It is best for communicating between Photoshop and Quark, Illustrator, FreeHand, and PageMaker. It allows clipping-path information to be saved.

DISPLAY RESOLUTION

Display resolution refers to the number of pixels in a horizontal scanline multiplied by the number of scanlines. Film itself is not a digital medium and therefore is not measured in pixels, but in dots per inch (dpi). Film is a continuous-tone medium, like a photograph. However, creating digital sequences for transfer to film is measured in pixels.

FIELD DOMINANCE

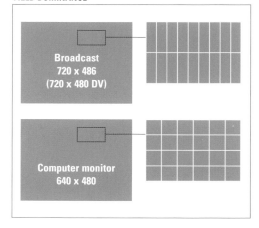

Broadcast
720 x 486
(720 x 480 DV)

Computer monitor
640 x 480

STANDARD VS. HIGH-DEFINITION VIDEO

Both analog and digital video displays represent each frame of video in the form of individual lines of horizontal resolution across the screen. Standard NTSC and PAL (see Color and Broadcasting Systems, page 026) are known as interlaced video formats. In these, the captured image is broken into two fields, each containing half of the total lines of resolution in a frame. In capturing images with a video camera, the first field is recorded, then the second, then both are captured on tape one after the other. During playback, a television monitor displays each recorded frame in two passes, drawing field 1 first and then field 2.

High-definition video, or video displayed on a computer monitor, uses progressive scanning, in which the resolution lines are drawn one at a time, from the top of the screen to the bottom. Video monitors use pixels that are rectangular. Computer monitors represent images using square dots known as picture elements, or pixels, arranged in a bitmap matrix.

Academy

standard television

Formats: video and 35mm film

Aspect ratio: 1.33:1 or 4:3

European Standard Widescreen

cinema film

Format: 35mm film

Aspect ratio: 1.66:1

American Standard Widescreen

HDTV, anamorphic DVD, wide DV

Format: 35mm film

Aspect ratio: 1.85:1 or 16:9

ASPECT RATIO

The display resolution correlates with the frame aspect ratio. QuickTime works in any frame aspect ratio, as long as it is rectangular. This creates more options for designers, but only applies to digital sequences that are for computer display. If the digital sequence is going to be transferred back to video or film, it must stay within the appropriate frame aspect ratio, or be letterboxed. To display a sequence from one format's frame aspect ratio in another format, a letterbox—black masking applied to the top and bottom of the frame—is used. Common frame sizes for video are presented on the right.

FRAME SIZE VS. PIXEL ASPECT RATIO

FRAME SIZE	ASPECT RATIO	PIXEL RATIO/APPLICATION
320 x 240	4:3	square pixel video frame for offline work
640 x 480	4:3	suitable for square pixel multimedia video
720 x 480	4:3	nonsquare video frame size for DV NTSC video
720 x 486	4:3	nonsquare video frame size for standard NTSC video
720 x 576	4:3	nonsquare video frame size for PAL or DV PAL video
1,280 x 720	16:9	square pixel resolution for high-definition video
1,920 x 1,080	16:9	higher square pixel resolution for high-definition video

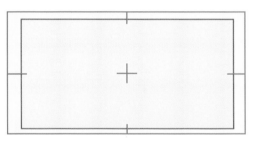

Everything in the universe goes by indirection.

There are no straight lines.

TITLE- AND ACTION-SAFE

Title-safe and action-safe areas are essential zones for legibility: critical areas within the frame that will not be cropped off when viewed on different video monitors. Different video monitors can crop off the outer edges of the frame, so titles or particular actions that are critical should avoid the edges and stay within the title- and action-safe areas.

TITLE SAFE

ACTION SAFE

SEQUENCE EDITING

As motion graphics is time-based, the term "image" does not really suffice to describe the way multiple images and sequences are linked together. In filmic terms, a frame is the shortest moment in time captured on film. A shot is a continuum of frames composing one action. A scene is a series of shots edited together, but existing as only one component of the narrative. A series of scenes is edited together to compose a complete narrative sequence.

01 FRAME
02 SHOT (OR CLIP)
03 SCENE
04 SEQUENCE

TIME CODE

Time is measured by time code. The Society of Motion Picture and Television Engineers (SMPTE) code is the universal time code for synchronizing analog/digital video and audio equipment. Time is measured in hours, minutes, seconds, and frames. Film can be measured in SMPTE time code, but the preferred system is to measure in feet plus frames.

00:00:00:00
HOURS:MINUTES:SECONDS:FRAMES

0000 + 00
FEET + FRAMES

35MM FILM: 16 FRAMES = 1 FOOT
16MM FILM: 40 FRAMES = 1 FOOT

Media

MEDIA FORMATS

Film, video, and digital media can be categorized into specific formats: 35mm film stock, VHS videotape, and QuickTime, respectively, are examples of such formats.

FRAME RATE

This refers to the speed of projection (film) or display (video/digital media). It is measured in frames per second; 35mm film runs at 24fps, which means that 24 frames of the film run through the projector per second. Video can be 30fps (or more precisely 29.97fps) or 25fps. QuickTime sequences can have any frame rate. (See Technology 01: Animation, page 010, for the effect of frame rates on motion.)

SUMMARY

MEDIUM	FORMAT	FRAME RATE		DISPLAY RESOLUTION	
		NTSC	PAL	NTSC	PAL
VIDEO: ANALOG	UMatic	29.97fps	25fps	640 x 480	720 x 576
	Betacam SP	29.97fps	25fps	640 x 480	720 x 576
	Video8	29.97fps	25fps	640 x 480	720 x 576
	Hi8	29.97fps	25fps	640 x 480	720 x 576
	Super VHS	29.97fps	25fps	640 x 480	720 x 576
	VHS	29.97fps	25fps	640 x 480	720 x 576
		NTSC	PAL	NTSC	PAL
VIDEO: DIGITAL	D1/D2	29.97fps	25fps	720 x 486	720 x 576
	Digital Betacam	29.97fps	25fps	720 x 486	720 x 576
	Betacam SX	29.97fps	25fps	720 x 486	720 x 576
	DVCAM/DVC Pro	29.97fps	25fps	720 x 486	720 x 576
	Mini DV	29.97fps	25fps	720 x 480	720 x 576
	Digital8	29.97fps	25fps	720 x 480	720 x 576
FILM	35mm	24fps		2,048 x 1,536, 1,234, or 1,152	
	Super 16mm	24fps		2,048 x 1,234	
	16mm	24fps		2,048 x 1,536	
	Super 8mm	18 or 24fps		—	
	8mm	18 or 24fps		—	
DIGITAL	QuickTime	Any; 15 and 30fps are common		Any; common in 4:3 ratio:	
	AVI (Windows only)			640 x 480, full screen	
				320 x 240, ½ screen	
				240 x 280, ⅓ screen	
				160 x 120, ¼ screen	

COLOR AND BROADCASTING SYSTEMS

To further classify the various formats of video, there are three color and broadcasting systems used for broadcast television internationally. They differ in frame rate, aspect ratio, resolution, and color quality. To view videotape recordings made in one system in another system, they must be converted, and that requires a special videotape recorder or computer software.

NATIONAL TELEVISION SYSTEMS COMMITTEE (NTSC)

29.97 frames per second
484 scanline resolution

Used in Bahamas, Barbados, Belize, Bermuda, Bolivia, Canada, Chile, Columbia, Cuba, El Salvador, Jamaica, Japan, Mexico, Panama, Peru, Philippines, Puerto Rico, South Korea, Surinam, Taiwan, Trinidad, USA, and Venezuela

SÉQUENTIAL COULEUR AVEC MEMOIRE (SECAM)

25 frames per second
625 scanline resolution

Used in France, the former Eastern Bloc, parts of the Middle East, Asia, and Africa

PHASE ALTERNATION LINE (PAL)

25 frames per second
625 scanline resolution

Used in Afghanistan, Algeria, Andorra, Angola, Argentina, Australia, Austria, Bahrain, Bangladesh, Belgium, Botswana, Brazil, China, Cyprus, Denmark, Ethiopia, Fiji, Finland, Germany, Gibraltar, Hong Kong, Iceland, India, Ireland, Israel, Italy, Jordan, Kenya, Kuwait, Lesotho, Liberia, Luxembourg, Malawi, Malaysia, Maldives, Malta, Mozambique, Namibia, the Netherlands, New Zealand, Nigeria, Norway, Oman, Pakistan, Paraguay, Portugal, Qatar, Seychelles, Sierra Leone, Singapore, South Africa, Spain, Sri Lanka, Sudan, Swaziland, Sweden, Switzerland, Syria, Tanzania, Thailand, Turkey, Uganda, United Kingdom, Uruguay, Yemen, Zambia, and Zimbabwe

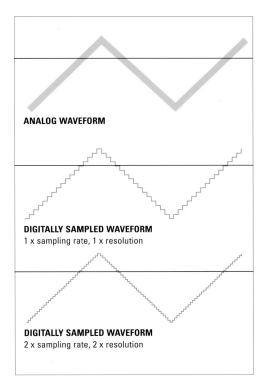

ANALOG WAVEFORM

DIGITALLY SAMPLED WAVEFORM
1 x sampling rate, 1 x resolution

DIGITALLY SAMPLED WAVEFORM
2 x sampling rate, 2 x resolution

VIDEO COMPRESSION

When an analog signal is digitized, it goes through a process called compression, or rendering. The term sampling, or data rate refers to how often the analog signal is digitized. The sampling rate is the main determinant of resolution: the higher the rate, the higher the resolution. Digital files can also be compressed. There are numerous compression choices, each depending on the intended use of the digital file. For instance, will it be shown on the Internet or burned on DVD? Will it be transferred to analog videotape or film?

CODEC: The process of converting the digital signal back to an analog signal is called decompression. There are various hardware- and software-based compression and decompression algorithms that can accomplish this. These are known as codecs—short for compressor/decompressor. Codecs minimize the file size of the sequence, and ensure smooth playback and cross-platform abilities for video and audio. Simply put, codecs compress the data using spatial and/or temporal compression techniques.

Spatial compression This removes redundant data within any given image by generalizing the coordinates and color of an area within the frame, ignoring the little details.

Temporal compression This looks at consecutive frames and retains only the elements of each image that change between each frame. Certain frames remain as an entire image—these are called key frames. The remaining frames, containing only the information that has changed between key frames, are called delta frames.

DIGITAL AUDIO

Digital audio is measured in sampling rates and bit resolution, which determine dynamic range. Digital audio can be either mono or stereo. Higher sampling rates and resolutions result in larger file sizes and a need for faster computer processing and storage, but provide a cleaner and better-quality sound.

Resolution (sample size) can be 8-, 12-, or 16-bit. Typical sampling rates are 44.1kHz, 32kHz, 22.050kHz, and 11.025kHz. Compression schemes can be utilized with digital audio to reduce the file size without much loss of quality. The sampling rate and bit resolution that is the most effective and appropriate for the audio component of your sequence is determined by the final format destination—film, video, Internet, CD-ROM, etc.

DIGITAL AUDIO FILE FORMATS

The two digital audio file formats are described below.

AIFF: Audio Interchange File Format. This is a cross-platform format that can use a variety of compressors to reduce file size. This is a lossy format—quality is reduced from compression. This format can be either 8- or 16-bit and uses sample rates from 8 to 48kHz.

WAVE: The primary format used by Windows-compatible hardware. This format can be either 8- or 16-bit and uses sample rates from 8 to 48kHz.

CODEC FORMATS

CAPTURING AND EDITING: The most common codec formats for capturing and editing digital video are listed here (and these formats can also be used for output and delivery). However, this is not a complete list. There are many other third-party formats available, usually based on the M-JPEG codec described below.

Apple DV-NTSC and DV-PAL Apple DV codecs used to capture video digitally from FireWire-enabled devices such as camcorders, decks, or analog-to-DV converters.

DVCPRO-50 Used to capture video digitally from FireWire-enabled DVCPRO-50-compatible camcorders and decks.

Apple M-JPEG A and B This is a lossy codec, similar to lossy image file formats. In video, the quality will be degraded and/or additional "artifacts" may be introduced to the image information. Variable data (sampling) rates are available, and these determine the overall quality of the image when compressed.

Photo JPEG This is similar to M-JPEG, but data loss is less severe at similar data rates. This codec may not play back in real time depending on the processing speed of the player (such as a computer) and the data rate.

OUTPUT AND DELIVERY: Because any given motion-graphics project is the work of many individuals, very often a single sequence must be delivered to multiple destinations. The best way to prepare a sequence for delivery is to output it as a full-resolution QuickTime format file, whether it is to be delivered on a CD-ROM, DVD, played on a computer, or streamed over the Internet.

Three factors must be maintained for successful output and delivery of video, similar to the output and delivery of still images for printing: file size, image quality, and file compatibility.

Uncompressed This is not a codec but is the best way to deliver a sequence because it is in its purest, original form. This is similar to the Raw format that many digital still cameras use to capture images.

Animation This was developed for computer-generated animated images, such as vector graphics that have areas of uniform color and very little "noise" found in live-action video. This is a lossless codec.

Several codecs are best used for specific delivery media such as CD-ROM, DVD, or Web site/Internet:

MPEG-1 This is designed for optimum playback at smaller data rates and is primarily used to produce noninterlaced 320 x 240 videos. This is the codec used for the Video CD format, which is different from DVD and DVD-ROM.

MPEG-2 This is the codec for creating high-quality and highly compressed digital video for DVDs.

MPEG-4 This can be created as a video format and a codec. It compresses video down to an extremely low bandwidth, yet maintains high image quality. This is a very popular codec for Web site compression and onscreen playback.

SORENSON This codec replaced the Cinepak codec. Like MPEG-4, it compresses video down to an extremely low bandwidth, yet maintains high image quality. It is also highly versatile and can be played on many platforms, including CD-ROM and Web site streaming.

Media

There are a number of factors that affect our ability to read type on a computer or video screen. These include the duration and speed of the words as they appear/disappear or move. The display resolution can drastically alter attributes of a typeface that were designed specifically to enhance its legibility.

While digital technology is slowly becoming the norm, there are a number of technologies involved in producing moving type—both analog and digital, and combinations of the two. Many traditional methods, particularly in film, offer what are often the most effective and inexpensive solutions.

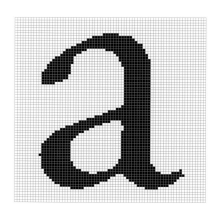

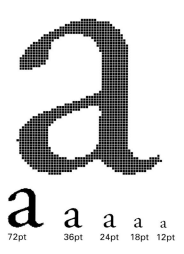

72pt 36pt 24pt 18pt 12pt

SCREEN FONTS

Letterforms and other typographic characters are represented on the computer screen by pixels. (See Pixels and Bitmaps, page 023.)

Because of the 72dpi display limitation of most computer monitors, screen fonts exist as individual, fixed-point-size files. Screen fonts are resolution-dependent.

ALIASING

The process known as hinting allows the computer to modify the shape of a character in order to look better at different sizes when displayed or printed at low resolutions. Normally, a screen font will instruct a pixel to turn on if more than half the area of the pixel is covered by the font. When the computer cannot render a typographic character properly on the screen, the condition known as aliasing or jaggies occurs, causing the character to appear stepped.

READING ON THE SCREEN

TYPE CHARACTERISTICS: The Univers family demonstrates how the display resolution can be detrimental to weight, width, and posture, reducing legibility in the typeface. Thin-stroked variations, especially the oblique faces, are the most affected by the grid-restricted pixel—in some cases, the stroke is not even evident. Stroke widths are not consistent, and the counterforms in heavier-weight typefaces appear closed. Letterspacing is inconsistent, and some letter combinations will read as one letter when they are too closely letterspaced. Additional tracking can reduce this effect.

Univers Light, 12 point

Univers Light Oblique, 12 point

Univers Regular, 12 point

Univers Regular Oblique, 12 point

Univers Bold, 12 point

Univers Bold Oblique, 12 point

Univers Extra Bold, 12 point

Univers Extra Bold Oblique, 12 point

Univers Condensed, 12 point

Univers Extended, 12 point

Typeface

TOPLINE
CAPLINE

MEANLINE

X-HEIGHT

BASELINE
DROPLINE

BEARDLINE

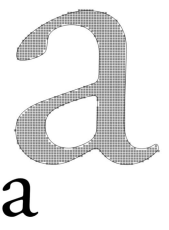

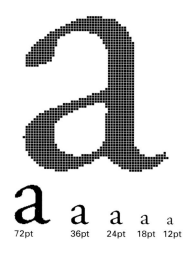

a
72pt 36pt 24pt 18pt 12pt

STAFF: The system of guidelines used to align characters evenly in a horizontal sequence. The four main components are: beardline, baseline, meanline, and capline. The topline is usually taller than an uppercase character. Letters with bowls or curved bases fall a slight distance below the baseline, to the dropline.

X-HEIGHT: The distance between the baseline and meanline of the lowercase character, minus the ascender and descender. The x-height varies in proportion with the ascender height and descender depth in different typeface designs.

PRINTER FONTS

Printer fonts are constructed from outlines of characters that precisely match the original typeface design. These outlines allow the printer to render a letter with smooth curves and angles, instead of the jagged, or aliased, construction of pixels. The outlines are also scalable, which means a single font file can be increased or decreased in size for output, without any sacrifice in the integrity of the typeface design. Printer fonts are resolution-independent.

ANTI-ALIASING

When a typeface is used strictly for screen display, the computer can reduce the jagged effect of the bitmapped image by averaging the color density of pixels at the edges of the character image with the background. This technique, known as anti-aliasing, gives the hard, stepped edge a soft appearance that simulates a smooth contour.

TYPE STYLES: Special effects—such as outlined and shadowed type—can also pose legibility problems. Script and serif typefaces do not render on the screen as well as sans-serif typefaces, particularly serif type with a large thick-to-thin stroke variation. Serifs will merge, and in some cases break up or disappear altogether. Nontraditional typefaces, many of which already pose legibility problems because of irregularities in their characters and overly stylized forms, are less successful on the screen than sans-serif typefaces, so their use should be restricted to display faces.

outline text
shadow text
Script typefaces
Serif typefaces
SERIF TYPEEACES
Thick - Thin stroked typefaces
Non-traditional typefaces
NON-TRADITIONAL TYPEFACES
Non-traditional typefaces

FORM

This section presents the primary component of both static and dynamic design: form. Generally, form is present in everything that is visible. Building upon the previous section, form has structure. Structure can generally be described in terms of point, line, and plane.

Form occupies space and, if the space is time-based, can move and change. A form can be captured statically or in motion, or created from source media, materials, or elements. Form can be representational or abstract. Form can convey meaning, or be absent of meaning and simply exist in and of itself—as decoration.

In motion-graphics design, form includes 2-D images, 3-D objects, and typography, usually separate from a background. Specific attributes of image forms include render, shape, size, color, surface, and dimensionality. Specific characteristics of typographic forms include case, face, size, weight, width, and posture.

Image · render

POINT
LINE
PLANE
PHOTOGRAPHIC
DRAWN
GRAPHIC

We perceive and interact in the world around us in three dimensions. The creation of a 2-D image is a man-made endeavor. Images can range from literal to abstract. This is a sliding scale of representation that is determined by the attributes of render, shape, size, color, surface, and dimensionality. An image can be rendered in many ways: it can be captured with a still camera; drawn in many different styles; or rendered graphically, with a hard edge and flat surface. Among the other effects that can be achieved are duotone, line art, continuous tone, and posterization. All of these are examples of literal use of imagery. Abstract imagery can function when a literal interpretation of the image is not desired.

POINT

LINE

PLANE

PHOTOGRAPHIC

DRAWN

GRAPHIC

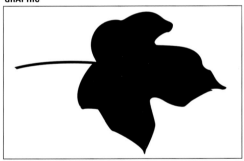

Image · shape

GEOMETRIC
ORGANIC
HYBRID

A single-image form can be expressed in terms of its general shape, or be a composition of different types of shapes: geometric, organic, or a hybrid of the two. The nature of the shape may contribute to the degree of representation or abstraction of an image form.

GEOMETRIC

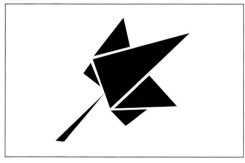

ORGANIC

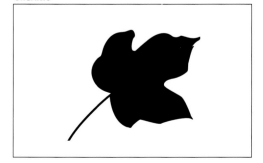

HYBRID

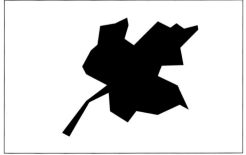

Image · size

SMALL
MEDIUM
LARGE

The apparent size of an image depends first on its relation to its frame of reference. The examples below use the same rectangular frame of reference to depict three different sizes of the same image. Secondly, it depends on its relation to other images or elements within a frame of reference. In this relationship, size is described as scale.

SMALL

MEDIUM

LARGE

Image · color

MONOCHROMATIC
POLYCHROMATIC
SOLID
GRADIENT

Color is used to enhance the presence of an image form. Color can be applied monochromatically or polychromatically, and can be solid or a gradient of two or more colors.

MONOCHROMATIC

POLYCHROMATIC

SOLID

GRADIENT

FORM

Image · surface

OUTLINED
SHADED
TEXTURED
PATTERNED

Surface can also be defined as fill, depending on the rendering of the image. If the image contains a distinct line around its contour, then the surface reads as a fill. If the image has no line defining its contour, then the surface reads as surface.

A surface can be shaded to simulate realism or material. A textured surface is defined by an irregular arrangement of surface elements. A patterned surface is a regular arrangement of surface elements.

OUTLINED

OUTLINED

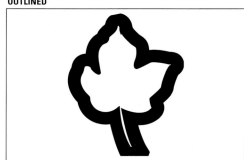

SHADED

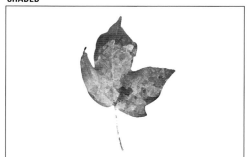

SHADED

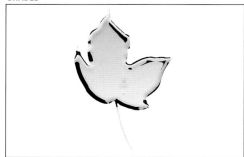

TEXTURED

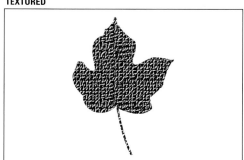

TEXTURED

PATTERNED

PATTERNED

Image · dimensionality

FLAT
SHADOWED
EXTRUDED
SIMULATED

Shadowing, extruding, and simulating are all methods of creating dimension in image and text forms. Creating a shadow behind graphic elements gives the illusion that they are suspended in a 3-D space. A relative hardness of shadow can simulate a direct light, while a relative softness can simulate a bounced or fill light. Shadows can also be used to create an interesting visual effect. Extruded objects appear to float in space because their direction is varied. The effect can be further enhanced by changing the position of the light source, which causes the letterforms to cast shadows on each other.

FLAT

SHADOWED

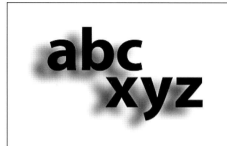

EXTRUDED

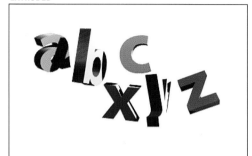

SHADOWED

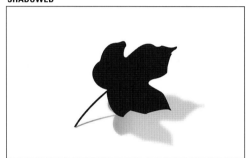

SHADOWED

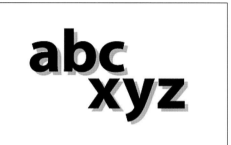

EXTRUDED

EXTRUDED

SHADOWED

EXTRUDED

SIMULATED

SHADOWED

Text

CASE
FACE
SIZE
WEIGHT
WIDTH
POSTURE

The particular characteristics of letters can be altered sequentially to bring attention to the meaning of a word, phrase, or sentence; to create visual hierarchy; or simply for formal experimentation. Transitions between the characteristics of a letter or word can also be used to emphasize the voice of the speaker in a situation where dialogue is being read, spoken, or both.

006 | 036

Style is nothing, but nothing is without style.

Style is nothing, but nOthing is without style.

Style is nothing, but NOthing is without style.

Style is nothing, but NOthing is without STYLE.

007 | 036

Style is nothing, but nothing is without style.

Style is nothing, but nothing is without style.

Style is nothing, but nothing is without style.

Style is nothing, but nothing is without style.

Style is nothing, but nothing is without style.

008 | 036

Style is nothing, but nothing is without style.

Style is nothing, but nothing is without style.

SIZE

Visual hierarchy is most easily achieved by altering the size of words and letters on the screen. The diminishing size of the words above further emphasizes "nothingness," while the increasing size of the word "style" makes a forceful statement. Large and small are relative to each other and most evident in a sequence when the scaling occurs over time. This also affects the spatial relationships between letters and words.

CASE

Uppercase letters traditionally mark the beginning of a sentence, and tend to possess a monumentality of form, which in turn gives emphasis and importance to a word. Lowercase letters form recognizable and distinct word shapes: the variety of lettershapes, ascenders, and descenders provides a contrast that benefits legibility. Attention is given to NO STYLE by the transition from lowercase to uppercase.

FACE

Type is categorized into three large groups (humanist, geometric, and hybrid), and two subcategories (serif and sans serif), but infinite variations exist within each group. The visual character of a typeface, which differentiates it from other typefaces, can give a word a particular personality. Altering typeface choice in rapid editing plays with the notion of style.

This sequence uses the typefaces Myriad, Dogma Outline, Keedy Sans Regular, Remedy Double, FF Erikrighthand, Dead History Roman, Bureau Grotesque-ThreeSeven, Serifa Roman, Bodoni Regular, Univers 55, and Minion Display.

009 | 037

Style is nothing,
but nothing
is without style.

Style is nothing,
but nothing
is without style.

Style is nothing,
but nothing
is **without** style.

WEIGHT

The thickness of the stroke relative to the height determines
the weight of a letter. Enhancing the meaning of the aphorism,
the ability to transition the word "nothing" from bold to light
supports the concept that style is becoming nothing, while
transitioning the word "without" from bold to extra bold
adds emphasis.

010 | 037

Style is nothing,
but **nothing**
is without style.

Style is nothing,
but **nothing**
is without style.

WIDTH

The proportion of a letterform relative to its height is known
as its width. The greater the width of the letterform, the larger
the counterforms and intervals of white between the strokes.
Scaling the words horizontally and vertically gives them
a life of their own.

011 | 037

Style is

Style is

Style is nothing,
but nothing
is without style.

Style is nothing,
but nothing
is without *style*.

POSTURE

The above sequence transitions from the upright to the
italic version of the typeface Myriad to alter its posture, or
stance. Italic and oblique typefaces possess a kinetic quality
because of their slant to the right. Animating the transition
from upright to oblique over time makes the kinetic quality
even more dynamic.

FORM

Supporting · line

HORIZONTAL
VERTICAL
DIAGONAL
CURVED

The use of ruled lines can add dynamic and highly active relationships in motion-graphics sequences. They can establish visual hierarchy and rhythmic patterns of movement, create visual focal points, suggest direction, and define space. Lines can be horizontal, vertical, diagonal, or curved.

013 | 038 DIAGONAL

Everything in the universe goes by indirection.

There are no straight lines.

014 | 038 CURVED

Everything in the universe goes by indirection.

There are no straight lines.

012 | 038 HORIZONTAL AND VERTICAL

Everything in the universe goes by indirection.

There are no straight lines.

Everything in the universe goes by indirection.

There are no straight lines.

Everything in the universe goes by indirection.

There are no straight lines.

Everything in the universe goes by indirection.

There are no straight lines.

Everything in the universe goes by indirection.

There are no straight lines.

Everything in the universe goes by indirection.

There are no straight lines.

Supporting · symbol

ALPHABETIC
ANALPHABETIC
NUMERIC
PICTORIAL

The addition of symbols can create a lively interpretation of text and other dynamic activity in motion-graphics sequences. A large-scale parenthesis or bracket can provide entry into a phrase, while an exclamation point and asterisk can add visual activity.

Symbols can be alphabetic, analphabetic, numeric, or pictorial.

015 | 038 ANALPHABETIC

erything in the universe es by indirection.

There ar

Everything in the universe goes by indirection.

There are no straight lines.

Everything in the universe goes by indirection.

There are no straight lines.

Supporting · shape

ORGANIC
GEOMETRIC

Similar to lines, shapes can add dynamic and highly active relationships to motion-graphics sequences. Shapes can define and structure the composition space, and enhance figure–ground relationships.

016 | 039 ORGANIC

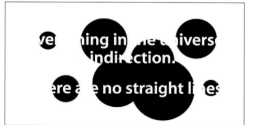

017 | 039 GEOMETRIC

Supporting · audio

VOICE AND ENVIRONMENTAL
MUSIC AND AMBIENT

A motion-graphics designer may be in a position to make design and editing decisions in response to the audio component of a sequence. Designing to audio (editing) requires a special time sense, which takes study and experience to develop. All designers should gain an understanding of the impact that sound can have, and should consider audio to be as integral to the message as image and type (see Rhythm, pages 068–069). For example, the opening titles for the film *West Side Story*, designed by the legendary Saul Bass, contained a two-minute visual overture synchronized to the theme of the main song, providing a theatrical atmosphere, establishing the visual character of the film, and preparing the audience emotionally for what followed.

VOICE AND ENVIRONMENTAL

As with imagery, sound can be categorized as literal or abstract. Literal sound is referential and is necessary to support reality. It conveys a specific meaning. Examples are words spoken by an actor or sounds associated with environments. It may or may not point to the originating source—we may or may not actually see the actor speaking.

MUSIC AND AMBIENT

Abstract sound, such as a musical score, is not essential to the content of a sequence and does not point to the originating source, but can enhance the message emotionally. The mood that audio evokes is an important factor in how a viewer reacts to a motion-graphics message. Two sequence examples that are identical except for the musical score applied can evoke a different response; one may place the viewer in a solemn, pondering state, while the other may create excitement and energy.

Semiotics

- SIGN COMPOSITION
- SIGN TYPES
- SIGN MEANING
- POINT, LINE, PLANE, AND VOLUME
- VERBAL LANGUAGE
- VISUAL INTONATION

Swiss linguist Ferdinand de Saussure (1857–1913) is considered the founder of semiotics, which is the study of systems of signs as part of social life. Here, the term "signs" has a wide definition and includes anything that represents something else. Signs can take the form of words, images, objects, sounds, and gestures.

Semiotics is the closest that the discipline of communication design comes to a body of scientific thought about how humans communicate with one another, and the devices we use to accomplish this. Semiotics has a vocabulary that can be used to describe how a sign looks and how it communicates in a specific social context.

SIGN COMPOSITION

Saussure proposed that a sign is composed of two parts: the signifier and the signified. The complete sign is a result of the relationship between these two parts.

Some linguists and philosophers have modified Saussure's two-part model and established different terms to describe essentially the same parts of a sign. The third part listed below—interpreter—considers the synthesis of all models.

SIGNIFIER: The form that the sign takes, or, what the sign looks like. Another term for this is syntax, which refers to the structural relationships between signs. This is similar to the syntax of written language: the rules that govern the structure and appearance of words, sentences, paragraphs, etc.

SIGNIFIED: The meaning attached to a sign. Another term for this is semantics—the relationship of a sign to what it stands for.

INTERPRETER: The relation of a sign to an audience reading a sign. Also known as the pragmatics, or function, of a sign. This takes into consideration the frame of reference of the reader, as well as the context of the reader in relation to the sign.

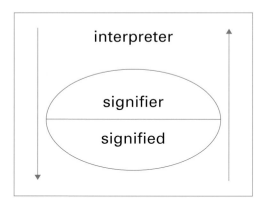

SIGN TYPES

There are four basic types, or categories, of signs, as described below.

ICON: A sign in which the signifier represents the signified by its likeness. For example, a photograph of a leaf.

INDEX: This measures meaning by a causal relationship to an object. Also known as a pointing sign, as the sign points to something else for its meaning: a tree branch points to a leaf.

SYMBOL: A sign by which meaning is established from an arbitrary relationship between signifier and signified. Meaning is learned through convention, or previous knowledge. For example, the spoken or written form of the word "leaf" represents the object leaf, rather than a bird, or a dog.

METASYMBOL: A symbol that has gained meaning beyond a one-to-one relationship over a period of time and/or a pervasive area of use. Other factors that contribute to the evolution of metasymbols include history, tradition, and culture. Metasymbols can be iconic in their recognizability.

ICON

INDEX

SYMBOL

METASYMBOL

METASYMBOL

SIGN MEANING

The meanings interpreted in words, images, objects, sounds, and gestures are denotative and connotative.

DENOTATIVE: Interpretation is explicit, self-referential, or iconic; the viewer does not necessarily have to work to recognize it.

CONNOTATIVE: Interpretation is implicit and suggests, or implies, a meaning beyond its denotation.

One reads an image differently from the way in which one reads a word. For example, the word "cat" connotes an image that may or may not be the same as someone else's. With a photo of a cat, however, everyone sees the same cat. The image does not suggest—in this context it denotes, or states.

When we read a book, composed of just text, two types of connotations exist. In the first, we compare the letters within groups to form words. We then compare words in each sentence to form a complete thought. Our grammatical conventions allow us to determine what is the beginning (an uppercase letter) and ending (a punctuation mark) of a complete sentence. The process continues as we compare sentences, paragraphs, and chapters to complete a whole.

At the same time, we are comparing these words and sentences to elements that exist outside of the book itself, in the paradigm. The meaning is not necessarily derived from the words we see, but from a comparison of these words to what we do not see. Our social and cultural persona enters, and we make associations from what we know and understand already—our influences.

The same two types of connotations exist when we view images in a sequence. The meaning of a specific shot/scene is derived from the shot/scene being compared with shots that precede and follow it. At the same time, we are making associations with elements that exist outside the frame, in the paradigm.

Point		Word		Frame
Line		Sentence		Shot
Plane		Paragraph		Scene
Volume		Text		Sequence

POINT, LINE, PLANE, AND VOLUME

Point, line, plane, and volume are conceptually tied to both the structure and composition of visual forms (image and text) and narrative sequences (film and video). In filmic terms, a frame is defined as the shortest moment in time captured on film. A shot is a continuum of frames composing one action. A scene is a series of shots edited together, but existing as only one component of the narrative. A series of scenes is edited together to compose a complete narrative sequence.

VERBAL LANGUAGE

The letters:

abcdefghijklmnopqrstuvwxyz

The word: **ambiguous**

The concept:

VERBAL LANGUAGE

Verbal language is a flexible system. Letters are utilitarian symbols used to represent language and have no meaning until they are assembled into words. A word is a sequence of symbols to which meaning is applied. In most cases, a word does not look like the idea it represents. The word possesses a sound (when spoken) and physical existence (when written). When the word is read, a mental image is created. Letters are at once representations of themselves and symbols for concepts when assembled into words and sentences.

VISUAL INTONATION

Expression of meaning can be accomplished through intonation or modulation of a voice—the tone of voice when someone is speaking. Words can be visually animated to simulate the intonation an actor might use, or to support the definition of a word.

VISUAL INTONATION

Color

PERCEPTION
HUE
COLOR WHEEL
PROPERTIES
BRIGHTNESS
SATURATION
TEMPERATURE
CONTRAST
RELATIONSHIPS

Color is the visible portion of the lightwave spectrum. Whether it comes directly from a light source, such as a yellow flame, or is reflected from an object, such as a red stop sign, our perception of color is subjective. If you asked a group of people to picture something blue, each one would visualize a slightly different color, yet if you showed the entire group all the colors visualized, they would probably agree that all the colors they imagined would fall into the category "blue."

Although the perception of color is subjective, we can measure and describe the properties of color with scientific precision. Various color models are used by scientists and artists to describe color in theory, that is, independent of reproduction technologies such as printers. This allows a standardization to exist between different inks, dyes, and other color agents.

PERCEPTION

Color perception involves the object, the context, the light source, and the viewer. The object affects perception by the way it absorbs and reflects light. Its context, or proximity to other objects, also has an effect, as does the light source, which may be sun, flame, or electrical (incandescent, fluorescent). Finally, the workings of the eye have an effect. The human eye has three types of cone, and each registers a different color: red, green, or blue. This is known as trichromatic vision. All colors can be matched in the visible spectrum using these colors.

PROPERTIES

Light has three characteristics that can be measured precisely by a spectrophotometer. Length is the most important characteristic, as it identifies the hue of the color. The length is determined by the distance from one peak to the next in a light wave. Amplitude identifies the brightness of the color and is determined by the height of the wave from peak to trough. The higher the peaks, the more energy in the wave and the brighter the color. Purity is determined by the number of wavelengths. A pure, or completely saturated color contains light of only one wavelength. As more wavelengths are added, the color becomes less distinct.

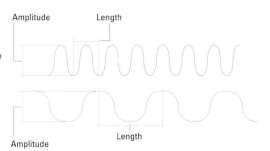

HUE

Technically, the hue is the color reflected from or absorbed by an object. Hue refers to the name of the color, for example, blue, red, and green.

COLOR WHEEL

This system is based on the three primary hues of red, blue, and yellow, as shown in the basic color wheel. The secondary hues in this system are orange, green, and violet. The color wheel also shows six tertiary hues, formed by mixing equal amounts of a primary hue and an adjacent secondary hue. A mixture of equal amounts of the three primary hues will form brown. This system is based on mixing color pigments.

Cool hues

Warm hues

Tertiary hues

Primary hues

Secondary hues

Tints of yellow

Shades of yellow

Warm hues

Cool hues

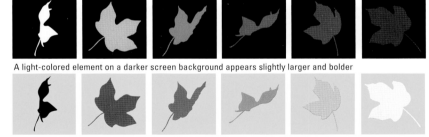

The intensity that is the result of the juxtaposition of two complementary colors is called simultaneous contrast. On the screen this intensity is amplified and it will appear as vibrating to the human eye. These examples are from the additive (RGB) color system, where the primary hues are red, blue, and green, and the secondary hues are cyan, magenta, and yellow

A light-colored element on a darker screen background appears slightly larger and bolder

A dark-colored element on a lighter screen background appears slightly smaller

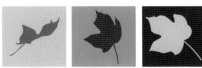

Monochromatic: a single hue and its values

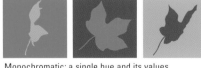

Achromatic: black, white, and gray hues and values

Complementary: any two hues directly opposite each other on the color wheel

Analogous: hues adjacent to one another on the color wheel

Split complementary: a single hue and the two hues on either side of its complementary

Neutral: a single hue and a percentage of its complementary or black

BRIGHTNESS

Brightness, also known as value, refers to how light or dark a hue is. A hue's intrinsic brightness increases with the addition of white (called a tint), and decreases with the addition of black (a shade). It is important to note that color created from light, the additive system, is unable to present colors with the same intensity as color created from pigment.

SATURATION

Also referred to as chroma or intensity, saturation refers to a hue's freedom from dilution with white, black, or another hue. A hue with no other colors mixed in is the most saturated form.

TEMPERATURE

Hues can convey the physical and emotional sensations of temperature. Reds, oranges, and yellows connote warmth, while blues, greens, and violets connote coolness.

Warm hues are more likely to cause color vibration because they are more likely to generate intensity when juxtaposed with white or light elements.

CONTRAST

The vibration of colors on a video or computer screen is caused by too drastic a contrast between foreground and background. This is an important factor in determining legibility. Strong color contrasts create distracting vibrations, while subtle contrasts make type difficult to see. Black backgrounds create the least amount of vibration on television and in film, so credits are often set white on a black background. The opposite is true of print, for which black type on a white background is the most legible.

RELATIONSHIPS

There are other hue relationships in addition to the primary, secondary, and tertiary relationships already discussed. The examples below illustrate the additive RGB color system with primary hues of red, blue, and green, and secondary hues of cyan, magenta, and yellow.

Color

HSB
CMYK (SUBTRACTIVE)
RGB (ADDITIVE)
CIE L*a*b
DEPTH/COLOR RESOLUTION
GAMUT
COLOR AND TYPE

There are several models of color reproduction. Each one has a separate function, but all are related. The subtractive color model is used to describe color that exists in pigment form and is applied to a physical surface, such as ink on paper, or paint on a wall. The additive color model is used to describe color that exists in light form and is emitted from a source, such as a flame, television, or computer monitor.

Each model is limited by its reproduction technology, be it a desktop printer, commercial press, or computer monitor.

HSB

Based on the human perception of color, this model uses three characteristics: hue, saturation or chroma, and brightness.

CMYK (SUBTRACTIVE)

The second model is based on the primary hues of cyan, magenta, and yellow (CMY), with black (K) added as a control, and commonly used by printers. The complementary hues are red, blue, and green. In the subtractive system, a mixture of the three primary hues, of equal intensity, will form black, and subtract toward white. The subtractive system works through the reflection and absorption of light. This is how we see color on a surface, such as paper. The surface of the paper reflects certain wavelengths and absorbs others; the color we see is from the wavelength that is reflected.

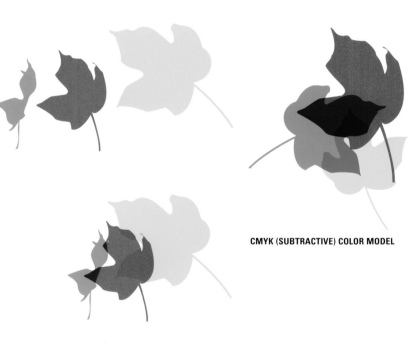

CMYK (SUBTRACTIVE) COLOR MODEL

RGB (ADDITIVE)

The third system is the additive system, based on the primary hues of red, green, and blue (RGB), which are the primary hues in light. The complementary hues are cyan, magenta, and yellow. In this system, mixtures of the three primary hues, of equal intensity, combine to form white, while the absence of all three produces no color (black). The additive system works through direct projected light; light that is visible from the source, such as light bulbs, the sun, and video and computer monitors.

CIE L*a*b

This widely used model was developed in 1931 by the Commission Internationale de l'Eclairage (CIE; International Commission on Illumination) as an international standard for color measurement, and refined in 1976. This model is device-independent, which means that color is consistent across multiple peripherals such as scanners, computers, monitors, and printers, including computer languages such as PostScript.

Color is defined by a luminance or lightness characteristic (L) and two chromatic characteristics: a (green to red) and b (blue to yellow).

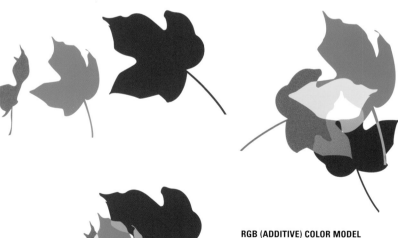

RGB (ADDITIVE) COLOR MODEL

DEPTH/COLOR RESOLUTION

In Technology 02, legibility, pixels, and bitmaps are discussed in relation to image resolution on computer monitors. The number of bits also directly determines the color resolution, or the number of color variations, that a monitor is capable of displaying. This is known as bit depth or color depth.

2 bits = 4 instructions

11 =		**100% black**
10 =		**75% black**
01 =		**25% black**
00 =		**0% black**

1 BIT
2 colors, black and white; no hue or saturation

8 BITS
256 colors or 256 shades of gray; can represent some information on hue, value, and saturation

24 BITS
16.7 million colors; each pixel is defined with 8 bits of information for each of the primaries: red, green, and blue.

32 BITS
16.7 million colors plus opacity levels

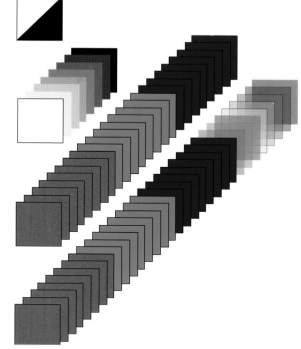

GAMUT

The human eye can see a larger spectrum of colors than can be produced in any color model, including the emulsions of photographic films and papers, computer and video monitors, and desktop and commercial printers. The range of displayable colors, called the color gamut, is different for computer and video monitors.

On a video screen, colors with a high saturation value will appear to bleed into each other. The range of colors that are not prone to bleeding are called video-safe or broadcast colors. Both the saturation and luminance of a hue can be adjusted to make it video-safe.

The television industry uses color bars as a standard for the color alignment between different cameras, monitors, and recordings. When distributing sequences on videotape, a minimum of 10 seconds of color bars should be recorded at the beginning.

GAMUT RANGE

VIDEO COLOR BARS

COLOR AND TYPE

The attributes of a particular typeface can also pose legibility problems, particularly when the contrast between background and type is too subtle or too strong.

Typefaces with very thin strokes or a narrow width, or of a very small size, create reading difficulties on the screen. Extreme color contrasts, which further impede legibility, should be avoided.

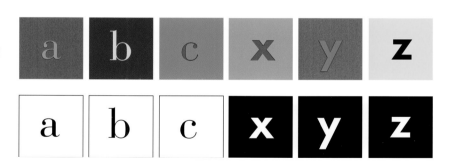

Time is the primary component that differentiates static from sequential, or dynamic, graphic design. In this context, time is composed of two parts: motion and sequence. Motion refers to actions that take place within the viewing frame, within each scene. Characteristics of motion include dynamics, direction, orientation, rotation, proximity, grouping, layering, and transformation.

Sequence refers to the linking of scene to scene in order to create a narrative. Characteristics of sequence include structure, juxtaposition, hierarchy, transition, rhythm/pace, duration/pause, and foreshadow/recall.

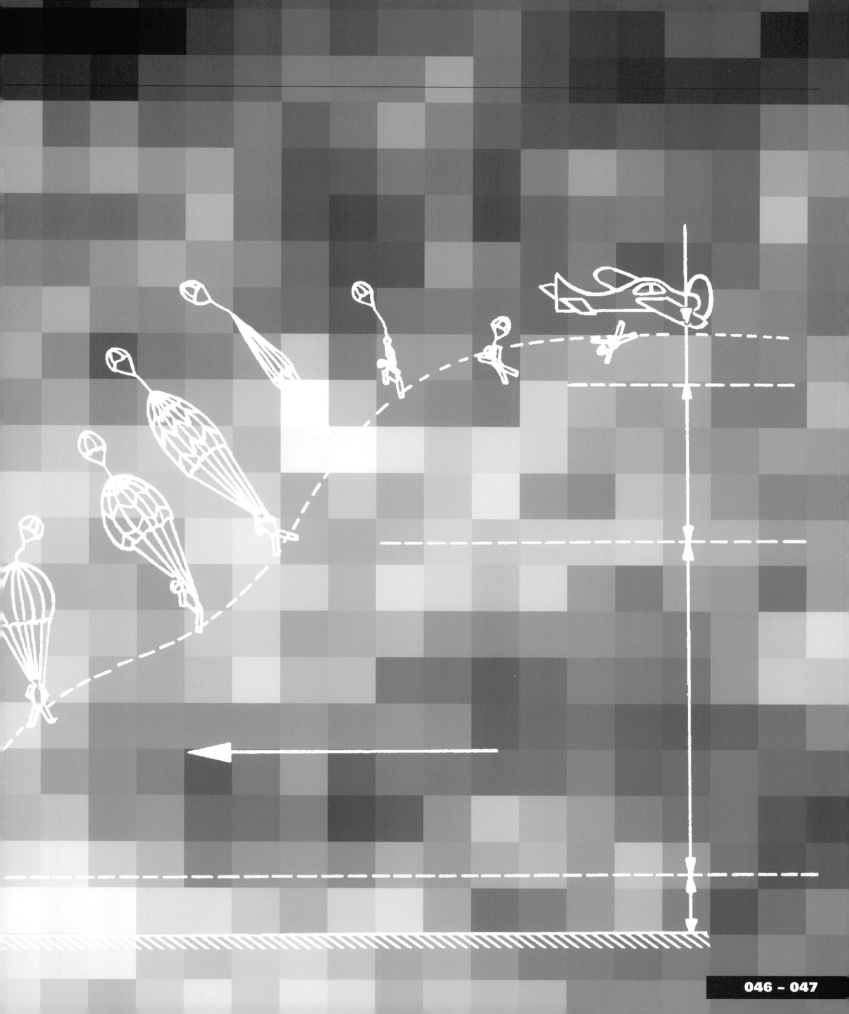

Motion · dynamics

REAL TIME
IMPLIED
ABSTRACT

Also known as kinetics, dynamics is defined as actions or forces that produce, change, or imply the motion of objects. In motion-graphics design, there are three basic types of dynamics: real time, also known as live action, implied, and abstract.

REAL TIME

Action that is occurring on its own—a car moving down a road, basketball players engaged in a game, leaves blowing through the air—and captured live directly with a motion recording camera. This is also known as live action. The example on the right presents a leaf captured as it falls onto a still body of reflective water. A drawing of a leaf can be animated over a series of frames to give the appearance of falling in real time. Real time does not necessarily mean live action.

018 | 048

IMPLIED

Implied motion is designed, but with a logic that collaborates with physics and time. To produce the example on the right, the designer observed an actual leaf as it fell to the ground. He then captured this leaf at several stages along its path with a still camera. With the aid of illustration software, the designer illustrated the leaf at these various key points. With animation software, the designer then generated in-between frames of the leaf fading from one key frame to the next to imply that the leaf is falling. The liquid is implied by the organic rings that emanate outward from the leaf.

019 | 048

ABSTRACT

Abstract motion is also designed, but includes motion that defies physical and/or temporal logic. Abstract motion depends on the audience making the connection from point to point.

020 | 048

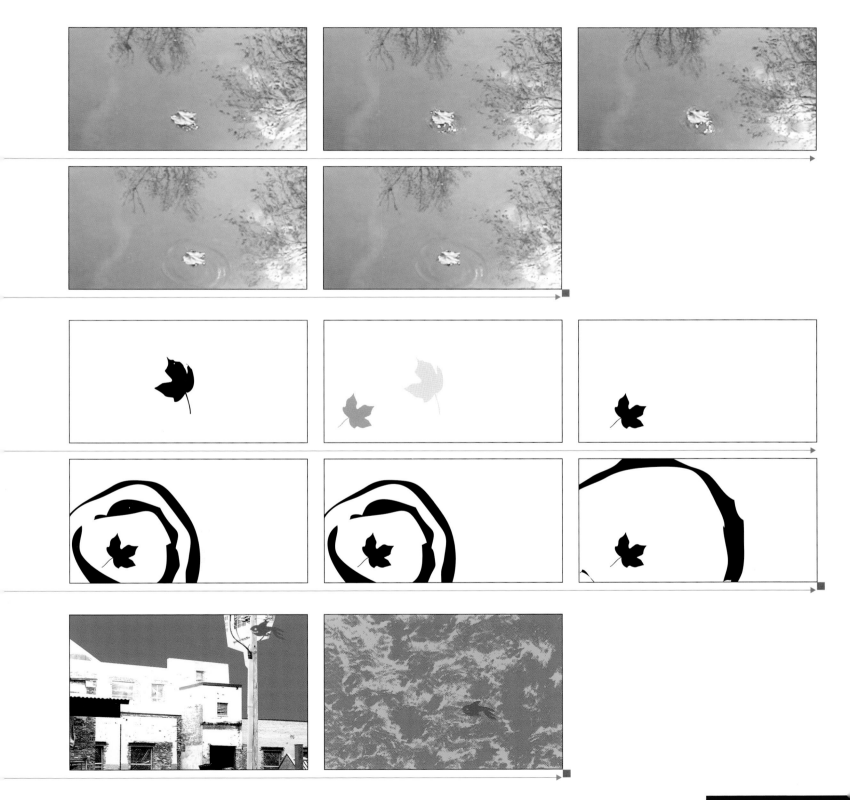

Motion · direction

STRAIGHT
CURVED
SPATIAL

In static communication design, direction refers to the way the audience reads a composition. For example, printed letters are conventionally arranged in words, and words into sentences, etc., on a horizontal baseline. For English, the reading direction is also horizontal, left to right, from upper left to lower right of a single page. The letters are static, the reading eyes move. When we refer to the direction in dynamic—motion—graphics, we are also adding the literal definition of movement.

Direction is the course or line of the movement. Direction can be straight (horizontal, vertical, diagonal), curved, and spatial (advancing, receding).

021 | 050 STRAIGHT: HORIZONTAL

022 | 050 STRAIGHT: VERTICAL

023 | 050 STRAIGHT: DIAGONAL

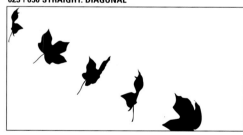

024 | 050 CURVED

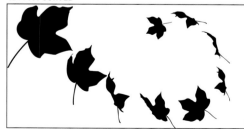

025 | 050 CURVED

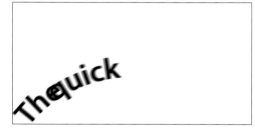

026 | 050 SPATIAL

TIME

Motion · orientation

UPRIGHT
RADIAL
INVERTED
SKEWED

Orientation is the directional position of the viewer in relation to the action. This is best identified with type; a letterform has an obvious upright orientation.

028 | 051 UPRIGHT

027 | 051 UPRIGHT TO RADIAL TO INVERTED

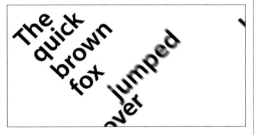

029 | 051 INVERTED

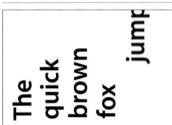
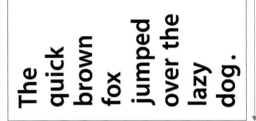

030 | 051 SKEWED

Motion · rotation

FLAT
SPATIAL
RANDOM

Rotation is movement around an anchor, or center point. This can occur with single or multiple elements within the viewing frame. It can also occur with the entire viewing frame itself.

031 | 052 FLAT

032 | 052 SPATIAL

033 | 052 RANDOM

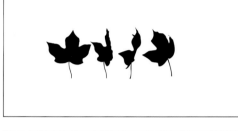

034 | 053 FLAT

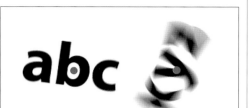

035 | 053 SPATIAL

abcxyz

036 | 053 SPATIAL

037 | 053 RANDOM

Motion · proximity

Proximity is the distance between elements in the viewing frame of activity. Proximity has the most relevance in situations where the elements must be read in a specific sequence, such as letters and words in text. Here, proximity includes the distance between letters, words, and lines of type created by altering the kerning, tracking, and leading relationships. Time-proven, optically measured parameters for good proximity remain important for legibility of text, particularly moving text on the screen.

SPATIAL

Interesting visual relationships and the enhancement of content can occur when kerning, letterspacing, and leading are all set into motion. The definition of a word or meaning of a phrase can be supported, or a discovery can occur.

Altering proximity can be very conducive to dialogue when the designer is attempting to capture the voice and emotion of the words being spoken. For example, increasing letterspacing visually supports the idea of satisfaction.

DELICIOUS
DELICIOUS
DELICIOUS
DELICIOUS
DELICIOUS
DELICIOUS
DELICIOUS
DELICIOUS
DELICIOUS
DELICIOUS
DELICIOUS

038 | 054

Curiosity is one of the permanent and certain characteristics of a vigorous intellect.

Curiosity is one of the permanent and certain characteristics of a vigorous intellect.

of a vigorous intellect. CURIOSITY

of a vig CURIOSITY ntellect.

C U R I O S I T Y

039 | 054

Unless one is a

intelligible.

Unless one is a genius, it is best

glitti leli b

Unless one is a genius, it is best
to aim at being

gl irti i e el b

Unless one is a genius, it is best to aim at being

eltgni le .

Unless one is a genius, it is best to aim at being

intelligible.

SEQUENTIAL

Sequential proximity ensures that the appearance of each word in the text appears in the exact, or a relatively close, vicinity of the word that preceded it. The intent should be to allow the eye of the audience to follow a consistent path and create a visual flow.

Words should not appear in random locations on the screen, as this makes it difficult for the eyes to assemble the text, which causes disorientation and impairs legibility. This problem will increase as the physical size of the frame increases. It is possible to break away from strict directional proximity as long as the eye of the audience is allowed to follow a consistent path. The diagram below shows the order in which the text appears from the first word through to the last.

040 | 055 TRANSITION CENTERED

Curiosity

041 | 055 TRANSITION RANDOM

① Curiosity ③ one
④ of
② is

⑦ and ⑨ characteristics
⑤ the
⑥ certain permanent ⑧

⑫ vigorous
⑪ a
⑬ intellect. of ⑩

042 | 055 TRANSITION AND DIRECTION

Curiosity is one of
the permanent and
certain characteristics

certain characteristics
of a vigorous intellect.

043 | 055 DIRECTION

Curiosity is one

and certain characte

044 | 055 TRANSITION AND DIRECTION

Curiosity
is
one of the
permanent

one of the
permanent
characteristic certain

characteristics certain
of a vigorous

intellect.
of a vigorous

Motion · grouping

SYMMETRICAL
ASYMMETRICAL
CONSONANT
DISSONANT

Related to proximity is the concept of grouping. As with proximity, grouping applies to both directional and transitional situations, but it is concerned with the balance (symmetrical or asymmetrical) and disposition (consonant and dissonant) of the elements within, and outside, the space of the viewing frame.

045 | 056 SYMMETRICAL DIRECTION

Do you wonder
that I was late
for the theater
when I tell you
that I saw two
Egyptians A's . . .

walking off
arm in arm
with the
unmistakable
swagger of
a music-hall
comedy team?

could do in
the fourth
dimension
of Time,
'flux',
movement.

046 | 056 SYMMETRICAL TRANSITION

Egyptians A's . . .
walking off
arm in arm
with the
unmistakable

swagger of
a music-hall
comedy team?
. . . after forty
centuries of

static Alphabet,
I saw what
its members

047 | 056 ASYMMETRICAL TRANSITION

Do you wonder
that I was late
for the theater
when I tell you
that I saw two Egyptians A's . . .

. . . after forty
centuries of
the necessarily
static Alphabet,

I saw what
its members
could do in
the fourth
dimension **of Time, 'flux', movement.**

048 | 056 ASYMMETRICAL DIRECTION

for the theater
when I tell you
that I saw two
Egyptians A's . . .
walking of

. . . after forty
centuries of
the necessarily
static Alphabet,
I saw what its members co

n of Time, 'flux', movement.

SYMMETRICAL

The frame consists of elements divided into parts of equal shape and size, and a similar position to the point, line, or plane of division. Symmetry implies correct proportion, comfort, and visual harmony. Film or television credits that scroll at the end of a presentation are a good example of type symmetrically composed and centered within the frame. Scrolls can be either directional or transitional.

ASYMMETRICAL

The frame derives its visual balance through the interaction of the elements with the negative space surrounding them. Asymmetry creates a visual tension through contrast of foreground elements and background.

Both directional and transitional sequences are shown here.

049 | 057 CONSONANT

Curiosity is one of
the permanent and
certain characteristics
of a vigorous intellect.

Curiosity is one of
the permanent and
certain characteristics
of a vigorous intellect.

Curiosity is one of
the permanent and
certain characteristics
of a vigorous intellect.

050 | 057 DISSONANT

Curiosity is o

the pe

one of

of a vigorous intellec

cteristics

051 | 057 DISSONANT–CONSONANT

Curiosity is one of

nent and

certain cha

f a vigorous intellect.

Curiosity is one of

rmanent and

certain charact

of a vigorous intellect.

Curiosity is one of
the permanent and
certain characteristics
of a vigorous intellect.

052 | 057 CONSONANT–DISSONANT

Curiosity

s) one of the
permanent
and certain
characteristics
of a vigorous
intellect.

CONSONANT

Consonant implies contraction, and a consonant disposition occurs when the disposition of elements is tightly arranged, or all the movement occurs within the frame.

Disposition is the arrangement of graphic elements in relation to each other and the edge of the frame. In cinematic terms, an open frame is one in which activity takes place outside the frame and view of the audience—frame as window. A closed frame is one in which all of the activity is within the frame and view of the audience—frame as room.

Particular to motion graphics is the ability to alter the disposition over time. Elements entering from outside the frame in dissonant arrangement can maneuver themselves into a consonant composition, and vice versa.

DISSONANT

Dissonant implies expansion, and a dissonant disposition occurs when the activity of the elements breaks the boundaries of the frame.

Motion · layering

Three different types of layering can be used to create different levels of opacity: opaque, translucent, and transparent. Varying levels of opacity can aid in determining visual layering from top to bottom, or front to back.

Tonality, closely related to opacity but not to be confused with it, refers to the depth of a screen color or the tint of an opaque color, that is, to the general lightness or darkness of the hue.

053 | 058

054 | 058

055 | 058

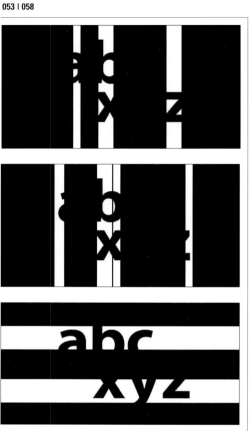

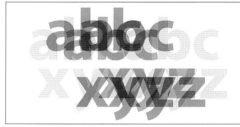

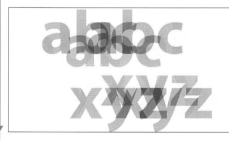

OPAQUE

Opaque refers to a state in which, with layered elements, the top layer completely covers and blocks the layers below. When working with simple color or a positive–negative palette combination, a type of layering can occur, much like a curtain pulling aside to reveal a stage set or prize.

TRANSLUCENT

Translucency is achieved when some light is allowed to pass through the layers. There are varying levels of translucency. When multiple translucent elements are layered, an optical effect known as ghosting can occur. Ghosting is a faint apparition left behind an image in motion. When translucent colors overlap, they mix in real time.

056 | 059

TRANSPARENT

Transparency is the state in which layered elements appear hollow. Outlined elements punched out of solid shapes allow all the layers to be seen.

057 | 059

058 | 059

059 | 059

SYNTHESIS OF TECHNIQUES

Opacity can also be effective over continuous-tone imagery: in the above case, an out-of-focus video of colorful lights functions as a background in which translucent and transparent letterforms allow the light to shine through at varying levels.

Moving, colored rectangles overlap to reveal letterforms beneath, their state of translucency allowing them to mix live to create a multitude of color combinations.

Motion · transformation

REDUCTIVE
ELABORATIVE
DISTORTIVE

Transformation involves changing some inherent nature of an element or elements over time. This process can be reductive, elaborative, or distortive. The transformation of elements can be accomplished in many ways, and most animation software programs give easy access to filters that allow an array of visual effects to be applied.

Reductive includes the removal of parts, as well as cropping and synthesizing. Elaborative includes enhancements such as filling, extending, and repeating elements. Distortive includes manually fracturing, or employing software filters such as blur, pinch, ripple, wave, spherize, and twirl.

060 | 060 REDUCTIVE: SYNTHESIS OF MANY TO ONE

061 | 060 REDUCTIVE: SUBTRACTION

The danger of success is
that it makes us forget the
world's dreadful injustice.

The danger of success is
that it makes us forget the
world's dreadful injustice.

The danger of success is
that it makes us the
world's dreadful injustice.

062 | 060 ELABORATIVE: ADDITION

The danger of success is
that it makes us forget the
world's dreadful injustice.

063 | 060 ELABORATIVE: ADDITION

The danger of success is
that it makes us forget the
world's dreadful injustice.

064 | 060 ELABORATIVE: ADDITION

065 | 061 ELABORATIVE: REPETITION

066 | 061 ELABORATIVE: EXTENSION

067 | 061 DISTORTIVE: FRACTURE

068 | 061 DISTORTIVE: SPECIALTY

069 | 061 DISTORTIVE: SPECIALTY

TIME

Sequence · structure

LINEAR
NONLINEAR

Structure refers to the arrangement and appearance of a sequence—how the content is organized and presented. Typically, film, video, and QuickTime sequences have a linear structure; they have a beginning, middle, and end. The term "linear" implies a unilateral direction toward a predetermined message.

Interactive hypermedia experiences, such as Web sites, have a nonlinear structure and multilinear content delivery. Their structure allows navigational choices and random access by the audience, thereby altering possible interpretations in the message or narrative structure.

SERIAL

A	B	C	D	E	F

FORESHADOW

A	E	B	C	D	E

LINEAR

A linear sequence can be arranged serially or by some other means determined by content. The first illustration above presents a sequence in which a set of events or elements, such as images, are linked in a straight line (linearly). Each image is an extension of the previous one, with an obvious stepwise progression, to tell a story from beginning to middle to end, usually according to the factor of time.

A nonserial sequence is a set of events/elements, such as images, that are linked by some other means, such as foreshadowing, recollecting, recurring, etc. In the second illustration above, event E is introduced immediately after event A, as a foreshadow of what is to happen at the end of the sequence. See opposite for the related topic of juxtaposing multiple elements/events in a single sequence.

NONLINEAR

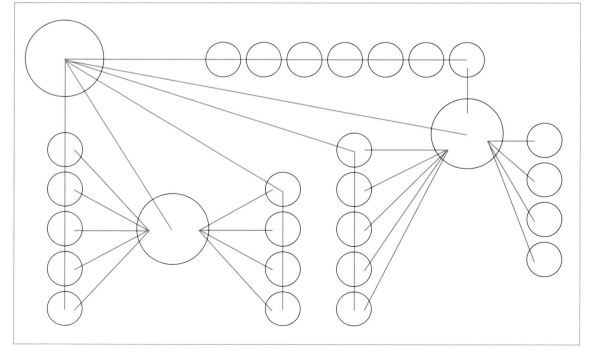

Sequence · juxtaposition

LAYERED

SEQUENTIAL

SIMULTANEOUS

In static communication design, to juxtapose visual elements, imagery, and typography is to place them side by side. Within the context of a time-based linear sequence, *dynamic* juxtaposition can occur. The elements can be layered, occur sequentially, or appear simultaneously with other elements.

Because of the dynamic nature of the sequence, the juxtapositions are in flux and often unstable. These three categories of dynamic juxtaposition are not exclusive; a sequence can be defined within the parameters of one, two, or all three categories.

070 | 063

071 | 063

072 | 063

LAYERED

Type is visually embedded—or interacting—within the image, resulting in the type functioning as image. Layered juxtaposition also occurs when the type overlaps the image.

SEQUENTIAL

Type and image appear within the frame alternately or successively. This type relies on memory, as the viewer makes connections between the elements as they occur.

SIMULTANEOUS

Type and image appear at the same time within the same frame and are visually separated, but not layered. A common use of this is the creation of zones of information.

Sequence · hierarchy

IMAGE-DOMINANT
TEXT-DOMINANT
AUDIO-DOMINANT
SYNTHESIS OF DOMINANCE

Hierarchy is an important component of sequence structure. This differs from visual hierarchy, demonstrated throughout the book with regard to graphic and formal characteristics, spatial relationships, and kinetics. Structural hierarchy is specific to the components of a sequence—type, image, and audio—when two or all three are present, and determines how a message is disseminated.

Sequential structure can be image-, text-, or audio-dominant. The dominant element is the main carrier of the message. The other two elements play a supportive role, and while they enhance meaning, they are not critical components in the understanding of the message.

073 | 064 IMAGE-DOMINANT

074 | 064 TEXT-DOMINANT

076 | 065

075 | 065 AUDIO-DOMINANT

SYNTHESIS OF DOMINANCE

A synthesis of hierarchy between type, image, and audio can, and most often does, occur in time-based sequences.

PARALLEL SYNTHESIS: This occurs when all three components are of relatively equal importance, but removing one of them will not affect the overall intent of the message.

INTEGRATED SYNTHESIS: This occurs when all three components are critical and must be present. Removing any one of them will drastically affect, or cause a collapse, of the communication.

Sequence · transition

WIPE
CUT
FADE
DISSOLVE
SPECIALTY

Transitions are beneficial to motion design because they are inherently dynamic. They are critical in establishing narrative sequence and emphasizing content. In early films, radial wipes implied that time had passed from one scene to the next; fades to black signaled the end of a particular moment; and dissolves from one scene to the next functioned as a comfortable formal device. Common transitions include cuts, wipes, fades, and dissolves. Specialty transitions utilize otherwise normal effects as formal devices. Words fading in and out are also easier on the eye of the reader.

Transitions can also emphasize content. Quick-cut edits support the concept of speed and energy, and can help to build to a climax. Transitions can also influence the reading of text; applying a slow-fade transition to a word suggests that it is to be contemplated.

077 | 066 LINEAR WIPE

 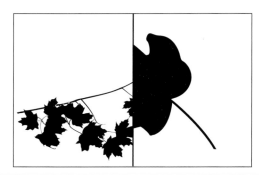

078 | 066 RADIAL WIPE

079 | 066 CORNER WIPE, RECTANGULAR

080 | 066 CENTER WIPE, RECTANGULAR

081 | 066 LINEAR WIPE, WITH BRANCH

082 | 067 FADE

Unless we *see* our subject,
how shall we know how
to place or prize it, in our
imagination affectation ?

083 | 067 DISSOLVE

084 | 067 SPECIALTY: ROTATION

085 | 067 SPECIALTY: BLUR

Unless we *see* our subject,
how shall we know how
to place or prize it, in our
understanding ?

Unless we *see* our subject,
how shall we know how
to place or prize it, in our
?

Unless we *see* our subject,
how shall we know how
to place or prize it, in our
imagination ?

086 | 067 SPECIALTY: ZOOM

087 | 067 DISSOLVE

088 | 067 SPECIALTY: ZOOM

Unless we *see* our subject,
how shall we know how
to place or prize it, in our
understanding ?

Unless we *see* our subject,
how shall we know how
to place or prize it, in our
imagination ?

Unless we *see* our subject,
how shall we know how
to place or prize it, in our
imagination ?

Sequence · rhythm

REPEATING
ALTERNATING
MULTIPLE

Rhythm is the movement characterized by repeating the same action, or alternating regularly, or irregularly, between different actions. Because rhythm occurs over time, pace is an inherent characteristic. Rhythm can be applied to the movement and occurrence of a single track of action within a scene, to multiple tracks of action, and to the length of multiple scenes.

There are several ways to design successfully with rhythm, including creating visual beats and contrasts in the pace of editing and movement, and paying close attention to the relationships between type, image, and audio.

089 | 068

090 | 068

091 | 068

REPEATING

Regular recurrence, or repetition, of an element can add emphasis or establish hierarchy. It also allows for a shorter duration of its appearance, as the repetition makes up for the time factor.

For example, a visual rhythmic beat occurs when repetition of a word, or a sequence of words, happens in a consistent manner. The viewer becomes accustomed to this visual repetition.

ALTERNATING

In addition to striving for an overall, comfortable rhythm and pace for a sequence, a designer can create contrasts in the pace of editing (duration, or length in time, of a scene) and movement between elements within the sequence. Elements can move at different speeds; one blurringly fast in the background, creating a type of visual texture, the others somewhat more slowly in the foreground. The alternation, or contrast, between them emphasizes the pace of all the elements.

Earlier in the book, the concepts of scale and tonality were mentioned as factors in establishing a sense of depth: an element close to the viewer and the edge of the frame is

larger and darker, while an element that is farther away is smaller and lighter. Pace adds to these factors; elements that are closer also move past the frame much faster, while elements that are farther away move more slowly. This occurs because elements closer to the fore-edge of the frame are larger and thus have a shorter distance to travel to cover the span of the frame than elements in the distance, which are smaller.

The overall phenomenon is known as *parallax* motion: foreground and background move at different speeds in order to simulate directional motion.

MULTIPLE

The relationship of the rhythm and pace of the visual elements (type and image) to that of the audio track can be categorized as synchronous (or parallel), and asynchronous, which can be further described as irregular and counterpoint.

In synchronous structures, the rhythm and pace of the visual elements is edited in perfect timing with that of the audio. In asynchronous, or irregular, structures, the rhythm and pace of the visual elements is uneven or inconsistent, while the audio is regular, and often prominent.

This relationship can also be reversed. In counterpoint structures, visual elements with a slow rhythm and pace are edited to an audio track with a fast rhythm and pace. These structural relationships between type, image, and audio are not exclusive—a sequence could, theoretically, contain any or all of them.

In audio, amplitude refers to the intensity or loudness of a sound. Typographic scale, weight, and tonality/opacity can create a visual relationship with the amplitude of the audio.

When making editing choices that determine rhythm and pace, remember that an overly consistent style can be predictable and monotonous. The key to rhythm is in the contrast.

092 | 069 TYPE, IMAGE, AND AUDIO RELATIONSHIPS

Even without the audio, the above sequence emits a detectable rhythm and pace in only two frames.

The diagram right shows the same visual elements combined with an audio track. Track 01 is consistent with the rhythm and pace of the audio, but progressively increases its pace. Track 02 is consistent and fast-paced throughout. Track 03 appears on every fourth beat; it is consistent but acts in counterpoint to the other tracks. Track 04 also acts in counterpoint to the other tracks, creating a consistently paced visual beat. Track 05 represents the audio component in visual wave form.

The other sequences listed are visually identical, but the audio track is not. Each audio track has a different rhythm, but shares the same pace. Therefore the rhythm and pace of the typographic elements is always even with the audio.

SYNCHRONOUS AND ASYNCHRONOUS

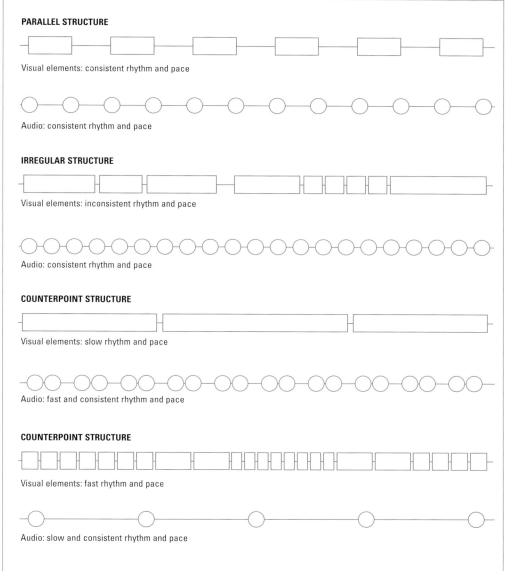

PARALLEL STRUCTURE

Visual elements: consistent rhythm and pace

Audio: consistent rhythm and pace

IRREGULAR STRUCTURE

Visual elements: inconsistent rhythm and pace

Audio: consistent rhythm and pace

COUNTERPOINT STRUCTURE

Visual elements: slow rhythm and pace

Audio: fast and consistent rhythm and pace

COUNTERPOINT STRUCTURE

Visual elements: fast rhythm and pace

Audio: slow and consistent rhythm and pace

093 | 069 TYPE, IMAGE, AND AUDIO RELATIONSHIPS

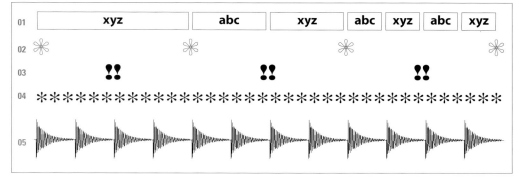

Sequence · duration and pause

FORESHADOW AND RECALL

Duration refers to the length of time an element appears and remains within the frame, moving or static; pause refers to the length of time between the appearance of one element and the next or the reappearance of the same element in repetition. Duration and pause have a direct correlation with the established rhythm and pace of a sequence.

Duration not only determines legibility in screen-based text—enough time must be allowed for text to be read—it can also be used to punctuate meaning and establish hierarchy. Pause allows time for the viewer to ponder what was presented before the next event occurs; a visual rest. It can also be used as a device to create anticipation—what will happen next?

A duration or pause that exceeds what is necessary can be laborious for the viewer, while too short a duration can hinder readability and cause disorientation.

FORESHADOW AND RECALL

Motion graphics are ephemeral, and the experience of them fleeting. Nothing is left when the sequence is over except an impression. Foreshadowing is used to warn of or indicate a future occurrence or event. Foreshadowing an image, word, or phrase creates a question that is later recalled (in normal sequence) to answer it. Recalling or repeating a word or phrase reminds the viewer of what has already passed.

094 | 070

I and **me**

I feel **me**

two~~two~~

In the sequence presented on these two pages, duration and pause are used as devices in the repetition of a phrase. *I* and *me* stay in the frame while *and* and *feel* appear sequentially to complete the phrase *I and me. I feel me*. This method is also utilized in the phrase opposite—*embodied in the language, as a whole*—with the word *embodied* remaining, and the word *reason* transitioning into *reasoning*.

Foreshadow and recall are employed with the word *two* appearing before the complete phrase *that makes two objects*, and then recalling itself, thus enhancing the concept of two by appearing twice. And again, less successfully, when the phrase *our philosophy is* appearing before *false*, although the complete phrase correctly reads *our false philosophy is*. The idea is to emphasize the word *false* by introducing it later.

that
makes
twotwo
objects

that
makes
two two
objects

our
phil**is**osophy

false
philosophy
is

one might say

E M B O D I E D

that we can't **reason**

E M B O D I E D
in the **language**

reas**on**g

E M B O D I E D
as a **whole**

without
reasoning

without
reasoning
wrong

Preproduction

SYMBOLIC SCORING

Preproduction involves the planning stages of designing a sequence before actual animation. This stage is essential due to the time-intensive nature of animation. It is during the preproduction stage of the design process that potential conflicts can be resolved, basic visual decisions made, and client approval on the concept at hand given.

Systems that can be used for preproduction planning include notation symbols for sequence scoring, traditional image-based storyboards, and text-only storyboards. The illustration below shows the use of notation symbols to score a typographic sequence.

SAMPLE NOTATION SYMBOLS FOR SCORING A SEQUENCE

SCORING TEMPLATE

SYMBOLIC SCORING

When a sequence does not include images, or is mainly composed of type, a traditional image-based storyboard may not be appropriate. Notation symbols can be used in conjunction with a scoring template to score the sequence. Time code indicates duration; the notation symbols indicate direction and transitions. An alternative to showing only the time code as an indicator of duration would be to extend the width of the frame in relationship to the other frames (see below), to illustrate duration in a more concrete visual manner. A note section exists for such information as typeface, size, color, specialty characteristics that are hard to sketch (like a blur), and audio information. The width and height of the frame in the template should reflect the actual frame aspect ratio.

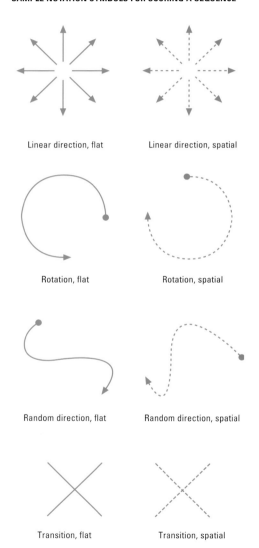

ALTERNATIVE TIME CODE

 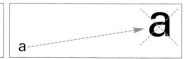

frame 01　　　　　　　00 : 00 : 01 : 00

Univers 55, 10pt, blue:
letterforms begin to appear randomly and multiply

Begin typewriter audio

frame 02　　　　　　　00 : 00 : 05 : 00

Letterforms continue to appear and multiply, and begin to move in a random flat pattern, exiting upper left frame

Typewriter audio continues; pace quickens

aframe 03　　　　　　　00 : 00 : 12 : 00

Letterforms stop multiplying, but continue exiting upper left frame

Futura Heavy "a," 48pt, black:
fade in 1 second, hold 4 seconds

Typewriter audio begins to fade out

frame 04　　　　　　　00 : 00 : 18 : 00

Fade out "a" 1 second

Futura Heavy "b," 48pt, red:
fade in 1 second, hold 6 seconds

Begin jazz audio, fade in, keep levels low

frame 05　　　　　　　00 : 00 : 26 : 00

Fade out "b" 1 second

Futura Heavy "c," 48pt, green: fade in 1 second,
hold 8 seconds

Univers 55 Cap "A," 0–72pt, black: 0%–100% opacity, exit
frame lower left, 2 seconds

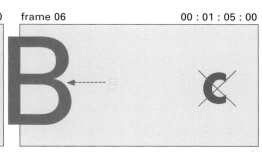

frame 06　　　　　　　00 : 01 : 05 : 00

Fade out "c" 1 second

Univers 55 Cap "B," 0–96pt, red:
0%–100% opacity, exit frame left,
2 seconds

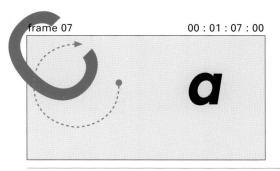

frame 07　　　　　　　00 : 01 : 07 : 00

Univers 55 Cap "C," 0–96pt, green:
0%–100% opacity, rotate 4 revolutions,
exit frame upper left, 3 seconds

Futura Heavy Oblique 48pt, black "a," 1-second stagger,
hold 3 seconds

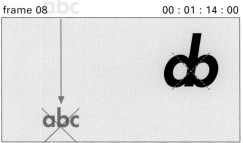

frame 08　　　　　　　00 : 01 : 14 : 00

"a" dissolves into "b," 3 seconds
Hold "b" 3 seconds

Futura Heavy ,"abc," 18pt, red: enters frame top, fades out as
it exits frame bottom, 3 seconds

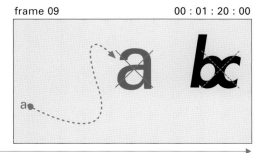

frame 09　　　　　　　00 : 01 : 20 : 00

"b" dissolves into "c," 3 seconds
Hold "c" 3 seconds

Univers "a," 0–60pt, green: random path to frame center,
5 seconds. Hold 3 seconds. Fade out, 1 second

Fade audio out

Preproduction

IMAGE-BASED STORYBOARDING

IMAGE-BASED STORYBOARDING

Discovery Channel's incorporation of state-of-the-art technology for producing its features was the catalyst for the direction of this ID spot.

M created a series of transitions to guide the viewer deep into ocean waters, glance into space, feel the wind blasts from a hurricane, and finally become part of a robotic process. The Discovery logo was progressively introduced during each of these transitions. The storyboard illustration on this page presents the concept before it is actually produced. The storyboard is a valuable aid in working out the sequence, from general concept to typographic detail. Sound design played a strong part in making the actions of each transition feel more dramatic.

The visuals on this spread consist of distinct stages leading up to implementation and animation. This page presents look-and-feel storyboards: detailed hand sketches that give the client an idea of tone and style. They introduce images, typefaces, frame aspect ratio, and basic navigation devices.

The facing page presents a storyboard with fairly detailed sketches in color. These give the client an idea of the concept of the animation as a whole. This storyboard uses computer-generated sketches. The eventual sequence does share elements with this storyboard, but more importantly, a storyboard gives the designers a point of departure.

DISCOVERY INTERNATIONAL: TRAVEL ID STORYBOARD

1. Window/porthole slams shut

2. Area fills up with water or window is submerged in water. Titanic footage layered into scene

3. Metal panel slides over porthole window

4. Inner panel opens up to reveal space travel

5. Space footage is layered with Discovery logo

6. With a quick twirling motion, Discovery comes into frame

7. Camera zooms from bird's-eye view to see that the Discovery logo is actually a weather device

Raging planet footage, i.e. tornadoes and hurricane layered in the background

8. Wind speed indicator is spinning in both directions. Storm clouds, lightning, and debris are flying all around

9. Robotic clamps come from top and bottom, transitioning over existing scene

10. Robotic devices meet together, tube mechanisms fill with substance and travel to center

Steam puffs out

11. Robotic device comes apart to reveal manufactured logo. As logo is revealed, globe is levered into position

Preproduction

TEXT-BASED STORYBOARDING

TEXT-BASED STORYBOARDING

A complicated, detailed sequence structure is sometimes most successfully planned out and demonstrated to the client using a text-based storyboard. Created by Sonya Mead, this storyboard is for a 90-second animation that shows the capabilities of the Digital HiNote laptop computer. It is divided into three 30-second sections that parallel the three characteristics of the computer that the client wanted to demonstrate: thinness, lightness, and power. The original has been altered to a vertical format and color has been added.

In addition to showing the structure of the animation to the client, this storyboard facilitates the important step of approval by the client, including the approval of imagery and text. This particular animation was released in six different languages, so the text needed to be approved before the translation process could begin. The storyboard also indicates the sound and rhythm of the animation.

The following page presents the final animation sequence.

images

tightrope walker	paper edge	feather	jockey	conductor	violin
popovers	rings of Saturn	flying squirrel	balloon	TGV	waterfall
CD	snake	hummingbird	glider	Concorde plane	fast food
saber	contact lens	clouds	spider	bullet & apple	gymnast in iron
foil	balance beam	waterbug	1% milk	Contrail	train sign
épée	laser	Calder mobile	bungee jumper	bat hitting ball	chameleon
train tracks	east wing	popovers	diver	tugboat	railroad light
crack of dawn	scull	Brooklyn	spiderweb	pulley	block & tackle
Flatiron	eclipse	Bridge		rollerblading	chessman
Building		butterfly		historic leader's	propeller
slice of sushi				wave	
corona					
venetian blinds					

text

1.1	wafer thin	4	freedom	1.33	stealth
skinny	svelte	weightless	freestyle	empower	prowess
hairline	horizon	agile	sleek	finesse	catalyst
				connect	

rough video everyday juxtaposed with clean images — *rough video everyday juxtaposed with clean images* — *rough video everyday juxtaposed with clean images*

THIN	LIGHT	POWERFUL/FAST	DIGITAL LOGO
SCREEN ATTRIBUTES a thin band that displays the images, dominant blue palette with others	**SCREEN ATTRIBUTES** the images float on the screen, dominant yellow palette	**SCREEN ATTRIBUTES** all images are in motion, dominant red palette	LOGO RESOLVE slabs of burgundy, changing color and typefaces
PRODUCT FEATURE VIDEO crack of colored light through door falls across the notebook	**PRODUCT FEATURE VIDEO** wind-up jumping chick upsetting the notebook or frisbee notebook	**PRODUCT FEATURE VIDEO** flyover of textural landscape of laptop opened, overspinning CD, past luminous speaker, mountainous keys	

STARTING POINT
collage of fast-paced actions, escalators, commuter trains, train signs changing, flights departing and arriving, soccer game

connectivity
multimedia
international
motion
music direction

STYLE 01: clean, easy, rock, international

STYLE 02: chorally, lots of airy voices

STYLE 03: techno

music pad

music pad

music pad

Preproduction

DIAGRAMMING AND PROTOTYPING

DIAGRAMMING AND PROTOTYPING

For this Discovery Channel ID spot, animal masks were used to introduce the theme of human storytelling pertaining to a human's relationship with the natural world. Elements such as sticks, shells, bark, straw, and feathers are part of a primitive palette in the creation of the masks used in this spot. These elements were interwoven with footage of animals on the run or in chase.

Logo designs wrapped around inner cylinder, spinning very fast

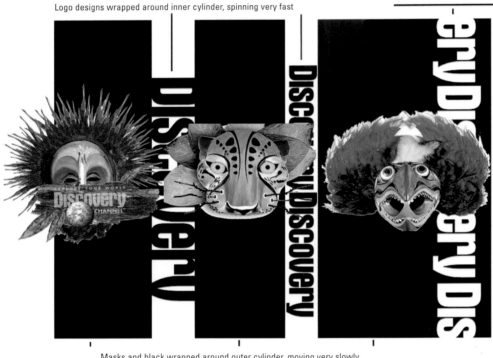

Masks and black wrapped around outer cylinder, moving very slowly

SPIN: Schematic

The layering of multiple detailed elements allows the viewer to bring a fresh perspective with repeated viewings. Repetition of the spinning Discovery logo also helps achieve a feeling of overall coherence for the piece. Sound design that includes samples from native drums to animal chatter becomes an integral part of the visual story revealed before the eyes of the viewer.

The arrangement and juxtaposition of real animal footage and symbolic animal masks is not accidental. These contrasts create relationships that have a meaning for the viewer and the identity of the Discovery Channel.

The schematic diagram on this page illustrates the device used to create the identity for this ID spot. When captured on camera, the spinning cylinders synthesize in a blur of imagery and text. The masks serve as transition devices that allow the insertion of live footage from the program series. Two cylinders are mounted vertically to a rotating ring, with one cylinder inside the other. The Discovery Channel logos wrap around the inner cylinder, which spins fast. The outer cylinder holds primitive masks, which spin slowly.

DESIGN PROCESS

The projects presented in this section
purposely have a theoretical and
experimental emphasis. This is the luxury of
having access to design and production tools,
a creative eye and mind … and the absence
of the client. A carefully constructed project
brief isolates specific, and important aspects
of the complex, convergent arena of motion-
graphics design, for in-depth study. This
allows the creator to identify, experiment,
learn, and even fail outside of the realities
of clients and budgets, and under the guise
of design process.

Virginia Commonwealth University, Richmond

MAPPING MOTION

This exercise is essentially a formal analysis of a professionally produced motion-graphics sequence. The objective is to reverse-storyboard the project in order to gain an understanding of time as a dynamic extension of static composition in a fixed space.

The analysis occurs on three tracks: verbal, abstract, and diagrammatic. The verbal track involves preliminary annotation—a literal outline of events as they occur—which is similar to a film script. The second track is an abstraction of the action; a macro view that purposely ignores representation of the specific visual elements. The idea is to capture and present a reductive essence of the actions and interactions that occur over space and time. The third track is a diagrammatic representation. This is a micro view of the activity that characterizes the quality of the visual elements and their relationship to one another.

Collectively, these three tracks capture all levels of activity in a motion-graphics piece. The end result is a process that can be used to plan forward from a concept toward final production.

TITLE: NIKE PRESTO
STUDENT: JOHN STANKO
INSTRUCTORS: ROY McKELVEY, MATT WOOLMAN

VERBAL STORYBOARD

For this study, Stanko used written language to describe what the visual language communicated to him:

FIRST ANIMATION

overview of city with vector animation of dj with ribbon
instant go bouncing to rhythm
buses and cars driving urban setting
moving background

SECOND ANIMATION

detail of speakers with rhythm
instant go bouncing to rhythm then wraps around building
close-up of building
still background

THIRD ANIMATION

instant go flows through the scene
tree and leaves bounce to the rhythm
roots grow
still background

FOURTH ANIMATION

roots continue to grow
man walks across the scene
speakers pulse to the beat
still background

FIFTH ANIMATION

roots get a lot more complex
speakers on wall pulse
side of building
still background

SIXTH ANIMATION

ribbon returns and flows through
elephant with smoking pipe
paint drips all over street
moving background

SEVENTH ANIMATION

three people standing
leafy birds move from left to right
ribbon wipes through
background moving

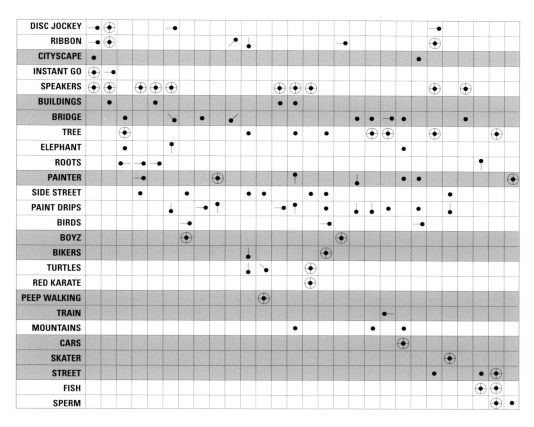

MOTION DIAGRAM

Taking some of the concepts that he learned while attending a workshop hosted by Edward Tufte, Stanko focused on reducing the visual elements and developed a graphic system to track the motion of the video. To do this, he created nine symbols representing the different kinds of movement, and used a 30% gray to differentiate between live action and the animated graphics.

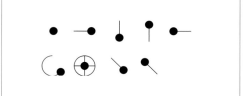

INTERPRETIVE STORYBOARD

One of the constraints of this project was to avoid using any screen captures from the professional piece. Often when creating digital video, either for a client or for oneself, it is difficult to represent the artist's vision until the video is captured. The traditional option is to show highly detailed storyboards. This is an exploration of more experimental methods of storyboarding.

Building from the verbal study, Stanko attempted to capture the mood of the video. He found this piece to be fast-paced with many repeating elements flowing from scene to scene. The illustration represents 15 seconds of the video. To storyboard this, Stanko developed a visual system to identify the different elements. Some of the elements are more literal, like the ribbon, and some are more iconic, like the red globes representing the speakers.

DESIGN PROCESS

Virginia Commonwealth University, Richmond

FORM PERMUTATION STUDIES

This exercise engages in a series of explorations involving motion studies and varieties of representation demonstrating and/or evoking the elements of "fire," "water," and "air." Any tool can be used to create, capture, or manipulate form—as still frames (images) or as multiple frames (time-based sequences).

Students are encouraged to engage in image-making and motion-capturing of elements and materials outside the computer, then translate the footage into bitmap/vector form for use in foreground action and/or background ambience and texture.

The primary objective is to gain proficiency in capturing and translating form as a means to an end. A morphology (presented at the beginning of this book) provides a guide to this process in order to engage in a stepwise exploration of permutating graphic form (image and type) and implementing this graphic form in space and time.

It is not necessary to consider all the attributes in the morphology for each study. The examples presented on these pages identify only the primary attributes.

095 | 084 WATER MOTION STUDY
STUDENT: PRYADASHI KHATRI
INSTRUCTORS: ROY McKELVEY, MATT WOOLMAN

A water study encouraged Prya to integrate other elements into a sequence. Here, she used the word "deceit."

MORPHOLOGICAL FOCUS:

2.2.1 TEXT: case: lower
2.2.2 TEXT: face: humanist
3.1.1 MOTION: dynamics: real-time
3.1.3 MOTION: orientation: upright/skewed
3.1.7 MOTION: layering: translucent
3.2.3 SEQUENCE: hierarchy: text

096 | 084 WATER MOTION STUDY
STUDENT: MEGAN URBAN
INSTRUCTORS: ROY McKELVEY, MATT WOOLMAN

Megan dripped various colored dyes into a container of water and captured the interactions of the two liquids. The example here presents several permutations into her study, where she has subdivided the viewing frame and juxtaposed several dye/water actions at differing orientations.

MORPHOLOGICAL FOCUS:

2.1.1 IMAGE: render: photographic
2.1.4 IMAGE: color: polychromatic
3.1.1 MOTION: dynamics: real time
3.1.3 MOTION: orientation: skewed
3.2.2 SEQUENCE: juxtaposition: simultaneous

097 | 085 WATER MOTION STUDY
STUDENT: PRYADASHI KHATRI
INSTRUCTORS: ROY McKELVEY, MATT WOOLMAN

This is an example of an initial study; capturing water pouring into a clear container. Prya then made subtle enhancements to the footage, identifying areas of focus within the morphology, listed on the right.

MORPHOLOGICAL FOCUS:

1.2.5 FRAME: depth: shallow
2.1.1 IMAGE: render: photographic
2.1.4 IMAGE: color: monochromatic
3.1.1 MOTION: dynamics: real time
3.1.3 MOTION: orientation: upright

DESIGN PROCESS

Virginia Commonwealth
University, Richmond

FORM PERMUTATION STUDIES

098 | 086 WATER MOTION STUDY
STUDENT: TERESA ENGLE
INSTRUCTORS: ROY McKELVEY, MATT WOOLMAN

This example shows several permutations of Engle's study of water. She has converted live-action footage into a richly textured composition of vector-based images linked together in a sequence to imply motion.

MORPHOLOGICAL FOCUS:

1.2.5 FRAME: depth: shallow
2.1.1 IMAGE: render: graphic
2.1.4 IMAGE: color: polychromatic
3.1.1 MOTION: dynamics: implied
3.1.7 MOTION: layering: opaque

099 | 086 FIRE MOTION STUDY
STUDENT: ANDREW ILNICKI
INSTRUCTORS: ROY McKELVEY, MATT WOOLMAN

This study demonstrates a series of permutations, beginning with live-action footage of a piece of paper burning. In subsequent stages, Andrew reduces the formal characteristics of the flame to simple shapes and lines while maintaining the essence of the flame's "flicker" motion.

MORPHOLOGICAL FOCUS:

2.1.1 IMAGE: render: photographic to graphic
3.1.1 MOTION: dynamics: real time
3.1.8 MOTION: transformation: reductive

100 | 086 FIRE MOTION STUDY
STUDENT: ANDREW ILNICKI
INSTRUCTORS: ROY McKELVEY, MATT WOOLMAN

This is a similar study to the one above, focusing on a more complex flame and conducting a specific permutation study.

MORPHOLOGICAL FOCUS:

2.1.1 IMAGE: render: photographic to graphic
3.1.1 MOTION: dynamics: real time
3.1.8 MOTION: transformation: reductive

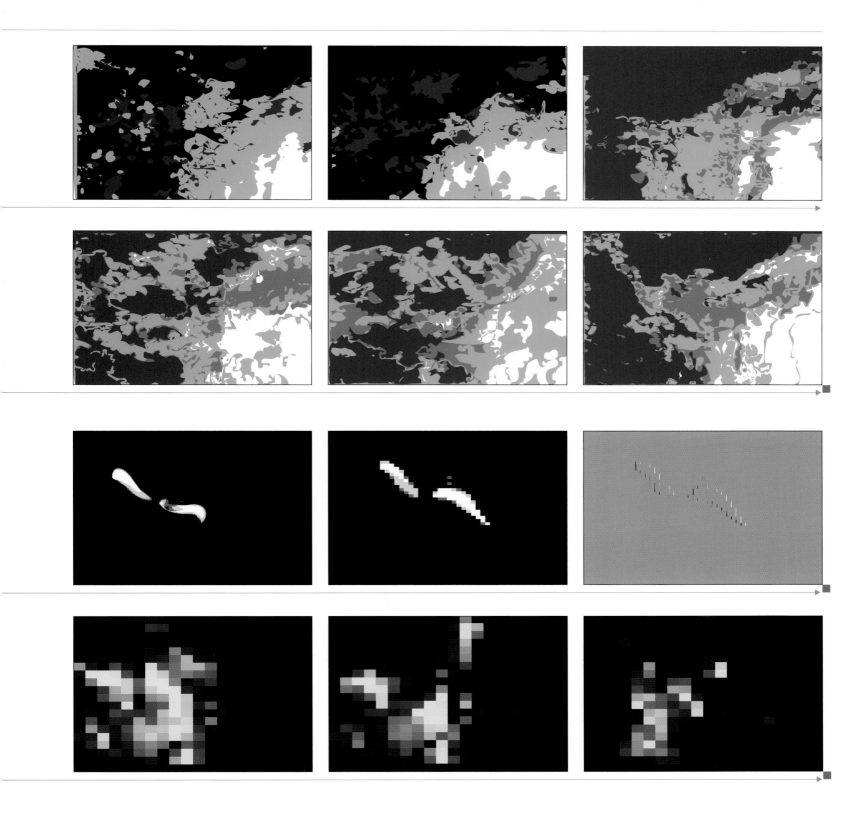

DESIGN PROCESS

Virginia Commonwealth University, Richmond

FORM PERMUTATION STUDIES

101 | 088 FIRE MOTION STUDY
STUDENT: RACHELE RILEY
INSTRUCTORS: ROY McKELVEY, MATT WOOLMAN

This study shows several permutations of a study of large-scale brush-fire flames. Rachele has reduced the original live-action footage to two-color, vector-based, animated shapes.

MORPHOLOGICAL FOCUS:

1.2.5 FRAME: depth: shallow
2.1.1 IMAGE: render: graphic
2.1.4 IMAGE: color: polychromatic
3.1.1 MOTION: dynamics: real time (animated)
3.1.7 MOTION: layering: opaque

102 | 088 FIRE MOTION STUDY
STUDENT: RACHELE RILEY
INSTRUCTORS: ROY McKELVEY, MATT WOOLMAN

This study presents subsequent stages beyond the above study. Here Rachele has introduced a background to create depth, and other graphic elements such as arrows and "smoke" in place of the actual flames.

MORPHOLOGICAL FOCUS:

2.1.1 IMAGE: render: graphic
2.1.2 IMAGE: shape: geometric and organic
2.1.4 IMAGE: color: polychromatic
3.1.1 MOTION: dynamics: real time (animated)
3.1.7 MOTION: layering: opaque

Virginia Commonwealth
University, Richmond

FORM PERMUTATION, APPLIED

This second part of the form-permutation
project focuses on the development of a
series of alternative solutions for a specific
message, using water, fire, or air as the
primary element. The element can have
a literal application (for example, water to
literally represent a river park system) or a
symbolic application (for example, water to
represent a spiritual organization).

103 | 090 WATER MOTION STUDY, APPLIED
STUDENT: MICHAEL GRAY
INSTRUCTORS: ROY McKELVEY, MATT WOOLMAN

Gray used his explorations of water as the basis for a series
of identities for an experimental film and music label, "Liquid
Fuxion." Pixelated, black-and-white permutations of water
are composed with type of a similar genre in quick cuts
from scene to scene to evoke the fluid yet raw nature of
pure experimentation.

104 | 090 FIRE MOTION STUDY, APPLIED
STUDENT: MARIUS VALDES
INSTRUCTORS: ROY McKELVEY, MATT WOOLMAN

Valdes used his explorations of fire as the basis for a series
of introductory sequences for a monster film matinee series
on the cable network TNT. First, Valdes formally permutated
a series of live-action clips of a Godzilla model and small
plastic army men burning. He then linked these clips with
transitions into a highly illustrative and dynamic sequence
that at once recalls the dramatic and yet camp nature of
classic monster films.

California College of the Arts

TEASER FOR FILM

This project asks a student to choose a film and create a teaser campaign for its DVD release. As a teaser, no footage from the actual film is allowed; rather, the student has to create original imagery and typography as a visual metaphor for the underlying themes of the film. In addition to writing the teaser script and redesigning the film's logotype, the student is encouraged to mix analog and digital production methods.

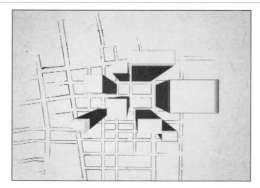

105 | 093 METROPOLIS
STUDENT: NICHOLAS MACIAS
INSTRUCTOR: JAMES KENNEY

This teaser was produced for the classic 1927 German science-fiction film *Metropolis*. The student focused on the film's futurist themes of city and artificial intelligence by three-dimensionally animating typography through street structures, building grids, and human anatomy.

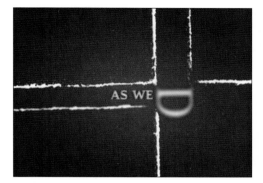
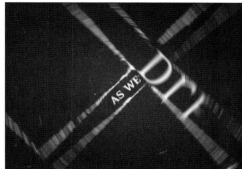

106 | 094 Z
STUDENT: JONATHAN BURKETT
INSTRUCTOR: JAMES KENNEY

This teaser was produced for the 1969 French film *Z*.
The film alludes to a military regime in Greek politics.
The teaser therefore attempts to subversively deliver the
truth and incite a revolution, but it is continually censored by
outside forces that wish to cover up the medical documents
of an assassination.

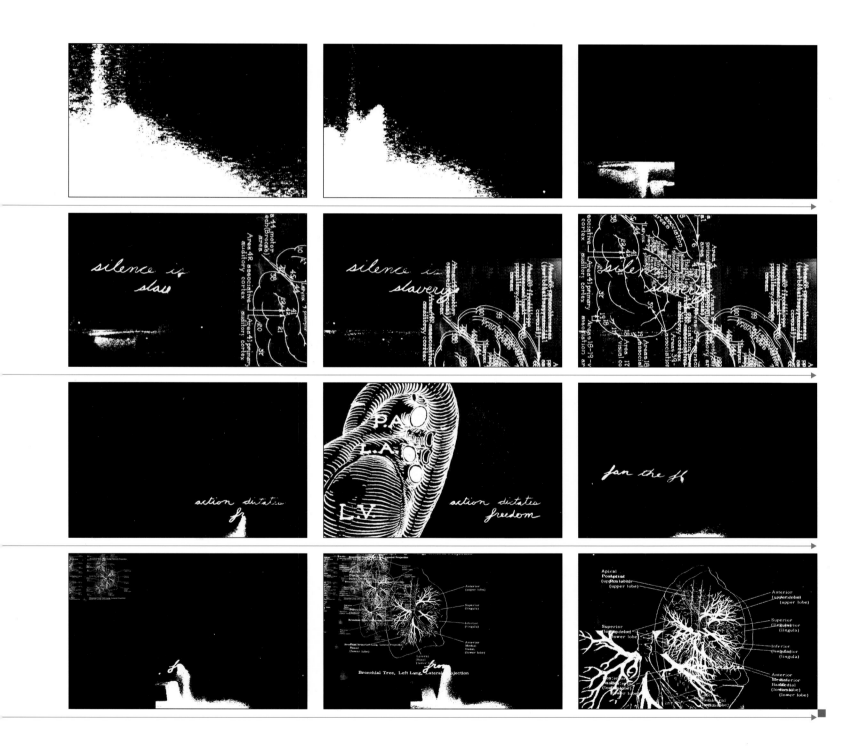

California College of the Arts

LOCUS FOCUS

This project asks a student to find meaning through the seemingly arbitrary intersection of a chosen site and an assigned theory from the fields of science, linguistics, economics, media theory, etc. Through the forced intersection of site and theory, the student develops new content and form. The student is encouraged to construct a new narrative that speaks to daily experience and connects to universal themes of the human condition.

107 | 097 BUG
STUDENT: MAKIKO TATSUMI ORSER
INSTRUCTOR: JAMES KENNEY

For this project, the student chose her car, an old Volkswagen Beetle. She was assigned to intersect this with a reading on microbiology. For her solution, she chose to draw parallels between herself as a young woman in the city and the way a bug might function within the human body. Each frame was hand-drawn from a series of photographs to create a cell-like animation. Typographic messages can be found within the transitions from scene to scene, as the "biology" of the animation itself transmutes.

DESIGN PROCESS

California State Polytechnic University, Pomona

*E*MOTION GRAPHICS

This project investigates the emotive qualities of graphics, text, timing, color, and space over a series of events that can be perceived as a whole or in part. The student is challenged to consider alternative methods for constructing graphic elements and type, including ambient patterns and textures.

The synthesis of two things into one unified concept is encouraged and fostered through debate, writing, and sketching. In addition, the act of filming should be used as a method to process information and to develop visual acuity. The tool should be used not only to capture motion but to engender creativity. The student is also encouraged to shoot each sequence from a multitude of angles and depths of field.

The overall objective is to seamlessly unify the technical concepts while expressing a common emotion in a unique way.

MATRIX

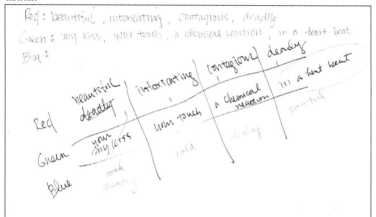

MIND MAP

TITLE: RGB
STUDENT: PORTIA TAM
INSTRUCTOR: SARAH A. MEYER

Presented on these two pages are initial process sketches to develop the project. The student engages various methods, such as a matrix, mind mapping, and storyboard sketches, to identify characteristics of the colors red, green, blue, and the word "curious."

MIND MAP

DESIGN PROCESS

California State Polytechnic University, Pomona

*E*MOTION GRAPHICS

TITLE: RGB
STUDENT: PORTIA TAM
INSTRUCTOR: SARAH A. MEYER

This project uses the colors of white light—red, green, and blue (RGB)—to define three segments of time-based emotion. Entitled *RGB,* this piece is introduced and encompassed by two additional segments; a title sequence and credits.

Projected light is used to display motion graphics via the screen or monitor; therefore, red (R), green (G), and blue (B) are the perfect points of departure for a visual experiment in motion graphics. The mixture of red, green, and blue light creates white while its absence creates black. Only with light can the human eye see; therefore, this piece associates the way we see things with the way we perceive things.

Each color of light is individual. Alone we see one color, but added together we see something that is totally different: white. The same can be said of people and passionate relationships. To the student who created this piece, this is the curiosity. Based on this oddity, she synthesized the colors of projected light with the cycle of love.

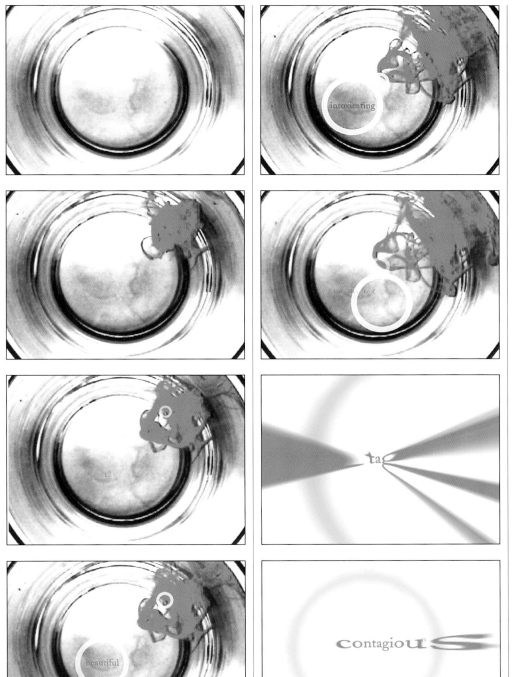

RED

Text from Tam's process book:

Red is the first stage of love. I believe the first sight of love is always beautiful and the first contact is intriguing and mysterious. In the first stage we begin to explore and find that everything our eyes behold is beautiful, including obvious flaws. Some say love is blind. I say love makes us see in a distorted perspective.

California State Polytechnic
University, Pomona

*E*MOTION GRAPHICS

GREEN

Text from Tam's process book:
Green is the second stage of love. We are compartmentalized in a space where only two of us exist. The physical bonding is a result of a chemical reaction that raises the body temperature. In this space and time everything happens in a heartbeat, blowing our minds away.

110 | 103 BLUE

BLUE

Text from Tam's process book:

Blue is the third stage of love. Cold like ice, we realize the heat has long gone. We try hard to keep warm by believing we can melt the ice. It is painful and foolish how long and slowly we let the blade carve deep into our hearts. Although it may be foolish, I believe that we do not learn from the experiences of life. We learn from the process of life in spite of the outcome. This makes up our memory.

CURIOSITY (closing sequence/credits)

Text from Tam's process book: *Curious has a dual meaning; strange or eager to learn.*

Because love is a curiosity to me I used this for the closing sequence for RGB. The circle of the magnifying lens references the circle in the title sequence. In addition, I used curiosity for a personal identity system. It reflects perfectly my eagerness to learn and enjoyment of the process of life.

The studios profiled in this section offer
a wide spectrum of professional practice
in motion-graphics design: television
commercials, program and network identities,
short films, and experimental products. Each
of the profiles has a unique visual voice and
engages a specialized creative process that
adapts to, and fulfills, the formal and
functional demands of our information-rich
communication cultures.

PSYOP

TELEVISION SPOTS

111 | 106 AT&T BROADBAND
FORMAT: TELEVISION SPOTS
CLIENT: AT&T BROADBAND

Created for AT&T's new broadband division, these television advertisements depict an austere, white backdrop in front of which "molecules" emerge, interact, synthesize, and race across the screen, to a percussion soundtrack. PSYOP were inspired to evolve the classic Saul Bass-designed AT&T logo. They worked with the limitations of basic colors and simple geometric shapes to communicate the idea of the convergent technology of broadband. The result is a series of graphic, metaphorical narratives.

New York City–based PSYOP is a creative collective that provides visual solutions for television advertisements and the broadcast industry. Founded in 2000 by three directors and two technical directors pulled from the ranks of MTV, the Sci-Fi Channel, Nickelodeon, and Lee Hunt, this collective is an inspiring culmination of creativity, collaboration, and production. PSYOP's appropriation of the United States government's division of psychological operations represents a critical awareness of the power that advertising has and the importance of accurate and targeted communications.

Through long-standing professional ties, creative relationships, and diverse technical expertise, PSYOP has evolved into an independent creative design and production squad dedicated to the cultivation of mind over pixel. PSYOP seamlessly blends the disciplines of design, animation, and live-action directing to create commercials for top brands including AT&T, Bombay Sapphire Gin, Intel, Ford, Lugz, Merrells, Starbucks, Volkswagen, and VH1. The company's advertising agency clients include Arnold Worldwide, Fallon, Euro RSCG/MVBMS, Ogilvy, and Merkley Newman Harty.

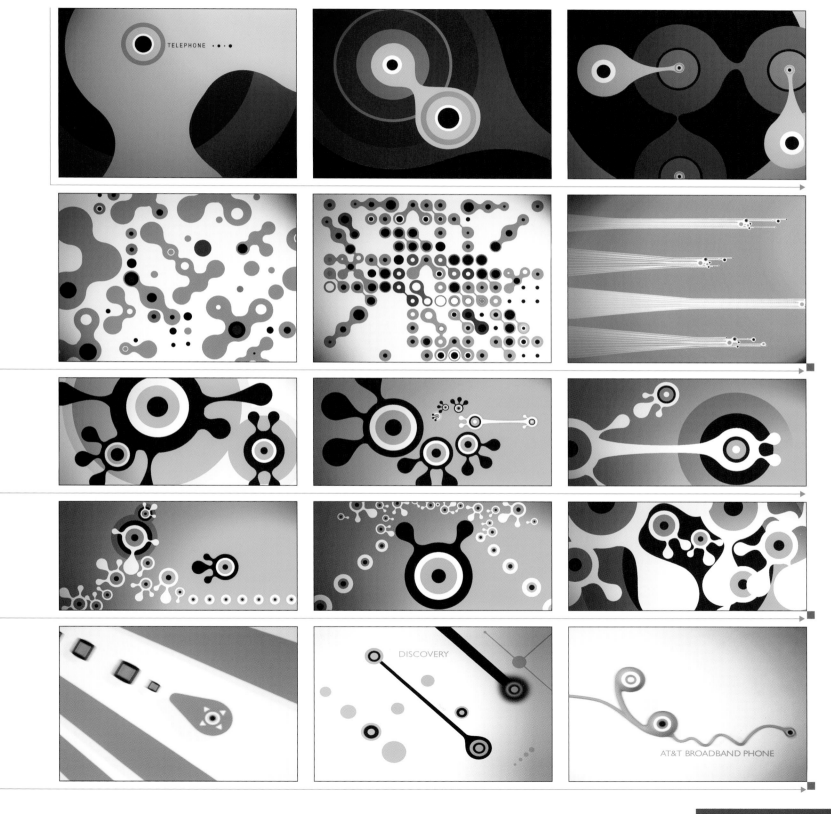

PSYOP

ART FILMS

112 | 108 COME FOR BRAZIL
FORMAT: ART FILM
CLIENT: DIE GESTALTEN

COME FOR BRAZIL

PSYOP was asked to submit a piece for a book titled *Brasil: Inspired*, published by Die Gestalten. The brief was to create something about Brazil, whether inspired from personal experience, something found there, or a random thought. PSYOP thought about how travel marketing creates international misconceptions about a country. In the US, Brazil is sold as if it were a red-hot "sex on the beach" party land. So the studio approached this piece as if it were creating an ad campaign for Brazil, their references being beach movies and porn. *Come for Brazil* is the outcome, literally climaxing with dolphins leaping out of the spray.

FORMAT: ART FILM
CLIENT: BOMBAY SAPPHIRE

DRIFT

Aiming to float viewers along a visual journey that reflects the elements of Bombay Sapphire's branding, PSYOP created *Drift*, a 60-second art film to promote the drink. Margeotes Fertitta + Partners gave PSYOP complete creative freedom, asking the company to create a piece that speaks to elements of the Bombay Sapphire brand, including alluring spirit, style, complexity, and depth.

PSYOP created a meditation that is also a love story. A man and a woman who never meet have a connection through the cause and effect of the natural events shown: a dandelion's drifting puff, a centipede dropping from a shaking branch, a coy languidly swimming in blue waters.

The commercial opens with the woman softly wishing on a dandelion, its floating puffs marking the first step on a poetic journey. Viewers drift through air and caress calm waters. They pass a coy curving through open sea and a bird landing on a branch, which shakes a centipede to earth. A dark, perhaps ominous, moment in *Drift* occurs when a centipede twists free of a tangle of roots, then rises to disturb a band of moths as they flutter toward light. The moths suddenly burst into a cluster of dandelion puffs, causing them to drift and land gently on the man's palm, and a wish is granted.

As directors, the PSYOP team built the story through performances, editing, and camerawork. For example, PSYOP wanted to move away from an understandable sense of space to create a sense of intrigue and otherworldliness—an emotional journey of substance and mystery. Viewers never really see a horizon line, or know how deep or shallow the space is because PSYOP chose to express space and environment through lyrical animation and camera moves. When the camera pans across the scene and subtly shifts to an overhead from a side-angle shot, it happens so organically that it does not feel jarring. Consequently, it delivers a sense of relaxation.

As designers, the team enhanced the story by paying specific attention to the composition, palette, and environment. PSYOP's visual techniques were inspired by traditional Japanese screen-painted panoramas, in which space is abstracted. PSYOP also developed the atmosphere of the commercial meticulously so that it had a waterlike, daydreamy quality. The blues undulate like reflections in a pond, giving the effect of looking through a bottle of blue-infused Bombay Sapphire gin.

PSYOP

MUSIC VIDEO

114 | 110 FORTUNE FADED
FORMAT: MUSIC VIDEO
ARTIST: RED HOT CHILI PEPPERS

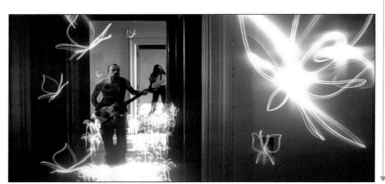

FORTUNE FADED

French director Laurent Briet collaborated with PSYOP to create the music video for the Red Hot Chili Peppers track "Fortune Faded." The music video is based on the story of a graffiti artist breaking into a hotel to create his art. Laurent's concept—to mimic the look of a moving light filmed with long exposures, but in 3-D space—originated with an experimental spec commercial that he created for Radiohead's "Like Spinning Plates."

To develop the glowing graffiti look in the video, PSYOP artists Eben Mears and Marco Spier worked as visual effects supervisors on set at Los Angeles' Ambassador Hotel, previsualizing every shot with Laurent as the shoot progressed. PSYOP then designed and built the graffiti elements in computer graphics, 3-D-tracked the live-action footage, and composited them together to achieve the realistic glows and flares in the final video.

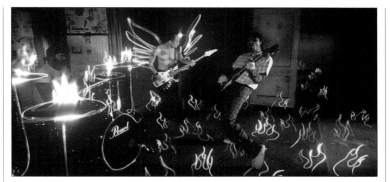

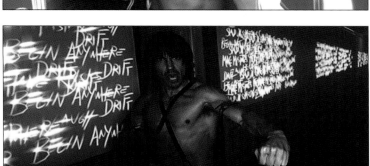

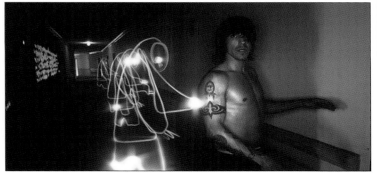

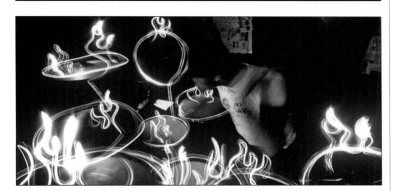

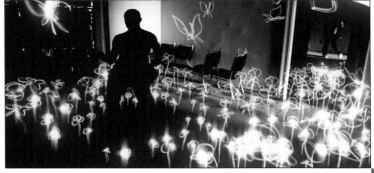

PSYOP

PROGRAM TEASER
TELEVISION SPOT

115 | 112 THE BLOCK
FORMAT: PROGRAM TEASER
CLIENT: ESPN

THE BLOCK

An unadorned yet distinctively colored cube travels from event to event, assuming the role of various objects in sport: drag racecar wheels, a football, a basketball, a bowling ball, a golf ball. However, the drag racecar cannot move with square wheels; the basketball cube does not fit through the hoop; the bowling-ball cube stops halfway down the alley; the football cube dribbles off the punting tee. The final straw is at the end of the putter, where the golf ball cube stops at the edge of a cup, punctuating the title of this program teaser, "The Block."

DARKNESS ACCELERATES

Using the language of the graphic novel for inspiration, PSYOP created a towering, dark, animated hero in the race of his life—a NASCAR driver hell-bent on beating the competition.

The package, which includes a 30-second graphically animated promo spot as well as a "tool kit" of animated elements, is beautiful and dramatic, with its use of stark, black-and-white computer-graphic animation. It was created for Fox Sports and the NASCAR 2004 race season.

The 30-second spot opens on the race car driver, shot from below, creating a sense of him as a dark hero at the beginning of a forbidding race. The ensuing scenes, told through comic-book-like windows, build the tension. PSYOP heighten the drama by using exaggerated close-ups of the main character's face, fast-paced scene transitions, and dynamic and realistic camera shakes and vibrations.

"In contrast to typical comic-book icons, we created a dark and dangerous hero using pure black-and-white textures and stark lines, and by playing with positive and negative space," say Marie Hyon and Marco Spier, Codirectors and Partners at PSYOP. "We wanted to depict a heightened sense of a driver's reality, highlighting the heroic quality of NASCAR driving."

PSYOP created the promo as a "tool kit" that includes individual close-ups of the driver and cars. The tool kit provides Fox Sports with the flexibility to tell different stories with the animation, or integrate the animation with live footage from the NASCAR race.

116 | 113 DARKNESS ACCELERATES
FORMAT: TELEVISION SPOT
CLIENT: FOX SPORTS TELEVISION

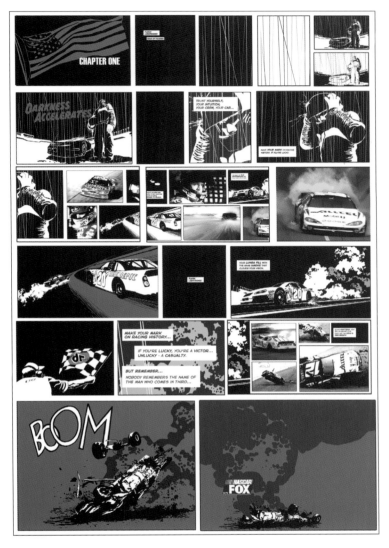

PSYOP

**TELEVISION SPOT
PROGRAM CATEGORY BUMPERS**

117 | 114 ARROW

**FORMAT: TELEVISION SPOT
CLIENT: LUGZ FOOTWEAR**

PSYOP directed, designed, and animated "Arrow," a commercial for Lugz Footwear that cross-pollinates the look of live-action film and hyper-real animation. Working with agency Avrett Free & Ginsberg, PSYOP created 10- and 30-second versions of the commercial. "Arrow" is set to the epic beats of DJ Funkmaster Flex.

"Arrow" is set in Lugz City, a sketched cityscape that is virtually transparent and vibrantly stained with a palette of orange and black colors, based on the Lugz brand. Against the surreal and layered backdrop of this metro environment, three characters breakdance in distinct scenes: a building rooftop, a city street, and an elevated outdoor subway station.

The breakdancers are visually connected to each other via a continuously moving, darkly textured 3-D arrow that courses through each scene. The arrow threads and boomerangs around each character, its movement integrally tied to their foot- and bodywork. The arrow is sent on to the next scene by a foot stamping the ground and then by hands cupping it like a sorcerer; it ends up darting around a spinning pair of legs.

Justin Booth-Clibborn, Executive Producer at PSYOP, believes that "as important as the animation was the look and texture we achieved. 'Arrow' transcends traditional looks in animation as the filmic quality of the spot bridges the gap between animation and live action. We conceptualized an alternate reality where all the elements, from color palette to design to character movement, work together to deliver a Lugz branding message that goes far beyond simply following a script."

PSYOP directed and designed "Arrow" so that the commercial and each character within it conveyed a high level of realism and lifelike movement. Working with XSI and Flame, and using many different textural elements like dry markers, drips, and ink spatters to integrate all the elements into one scene, PSYOP meticulously created the realistic character movement, and difficult-to-achieve details such as the shiny texture of the dark clothing, shoes, and arrow; the shading of the breakdancers' bodies; and the scattered flecks of dirt produced by fast footwork. As designers, PSYOP enhanced the story by paying careful attention to composition, palette, and environment. As directors, PSYOP built the story through the performances, editing, and camerawork.

118 | 115 MY MUSIC AWARDS
FORMAT: PROGRAM CATEGORY BUMPERS
CLIENT: VH1

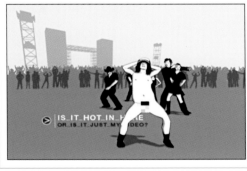

MY MUSIC AWARDS

The series of spots for the My VH1 Music Awards depicts 2-D, iconic human figures dancing and behaving like live-action humans, set in a reductive, multitoned blue background devoid of any characteristics found in real, physical, space. The characters are isolated, but within the same space, similar to the paintings of Edward Hopper. This awards show is completely fan-driven, from the category names ("Your Song Kicked Ass but was Played Too Damn Much") to the nominee and winner voting, all determined online. According to PSYOP, the overall experience is information graphics coming to life, visually representing the statistical input from the VH1 fanbase online voting. This was expanded with the characters breaking out of this system to become their own identities in an ethereal social space. PSYOP modeled and animated over 200 characters. In some scenes, 2,500 characters appear and interact seamlessly.

PSYOP

TELEVISION SPOT
SHORT FILM

119 | 116 DNA
FORMAT: TELEVISION SPOT
CLIENT: VOLKSWAGEN

DNA

These 30- and 60-second spots begin with a strong, fluid black line rapidly tracing the screen, multiplying itself into an engineer's sketch of a sixties' Volkswagen beetle. Several scenes ensue. In each, the centerpiece is the Volkswagen as it has appeared through the sixties, seventies, and eighties, up to today. The animated environments merge seamlessly together and rapidly transport the viewer from one to the next through "portals," including an engineer's clipboard, a car mirror, and a driver's sunglass lens.

To create the commercials, PSYOP collaborated with Arnold Worldwide and renowned illustrator Evan Hecox. Bringing the look of the commercials, based in part on Hecox's illustrations, to 3-D life led to a stunning display of PSYOP's animation and design capabilities.

The first commercials show minimalist, animated landscapes populated by grid-like patterns of characters and cars that are stained with soft, vibrant, monochromatic red, slate, green, and orange colors. They give viewers the sense that they are darting weightlessly around and through a Volkswagen world.

Volkswagen
Makes it better.

120 | 117 PSYOP ANTHEM
FORMAT: SHORT FILM
CLIENT: PSYOP

PSYOP ANTHEM

Persuade, Change, Influence: Buying Back the Real You. This short film is a children's musical sing-along commentary on faith and consumerism. The anthem continues PSYOP's proud tradition of media manipulation and cultural satire.

Come one, come all and follow me

We're off to support the economy

'Cause the world is full of things to buy

And folks are always wondering why

Which products best reflect themselves

When browsing through the aisles and shelves

And that's where PSYOP comes in

We make those eyeballs crave and spin

By dazzling you with sights and sounds

That lift your feet right off the ground!

"Persuade," "Change," and "Influence"

Of course you need our guidance

Our magic is based on simple rules

You will not learn about in schools

'Cause something's gotta keep us goin'

And keep that mighty cashflow flowin'

That's where PSYOP comes in

We'll make your eyes crave and spin

You'll never notice you are dying

Just as long as you keep buying

So come along and join the ride

Lean back your head and open wide

Digital Kitchen

NETWORK PROGRAM IDENTITY BRAND PACKAGE

TELEVISION SPOTS

At the center of contemporary design, filmmaking, and visual culture for over 15 years, Digital Kitchen (DK) demonstrates an uncommon capacity to understand and embrace convergent disciplines, including design, live action, sound, and music as well as strategic product and consumer maxims.

The creative environment at DK is patterned after the processes found in ad agencies, yet they do not limit themselves to traditional advertising models. DK also draws from a much broader creative palette than traditional design, marketing, or production films.

DK is a creative entity first and foremost. Unbound by the limitations inherent in traditional "brick-and-mortar" systems, DK considers motion content to be the preeminent consumer franchise-builder of the twenty-first century.

With a cross-disciplinary foundation in marketing, entertainment, and business and brand development, DK has assembled a list of premier clients including Nike, Adidas, Budweiser, Coca-Cola, ESPN, General Motors, Sears, Sony, Ford, Chrysler, Acura, and Columbia Pictures.

121 | 118 THE BEST WE GOT, FRIDAYS
FORMAT: NETWORK PROGRAM IDENTITY BRAND PACKAGE
CLIENT: CARTOON NETWORK

THE BEST WE GOT, FRIDAYS

Developed to promote the Friday lineup on Cartoon Network, this animation draws its motivation from the often overly dramatic world of blockbuster action-movie trailers. Dramatically lit, glassy elements move the viewer through a cold, dark space. A powerful voice booms as the sound effects shake the room. Suddenly, a series of funny, animated cartoon characters (the Friday lineup) appears. The result is both humorous and visually dynamic.

122 | 118 DO NOT, WATCH, ZONES
FORMAT: TELEVISION SPOT
CLIENT: ESSO

DO NOT, WATCH, ZONES

In this series of animated international commercials for ESSO oil, a roadside journey is depicted over, around, and through various environments, each based on geography relative to the country (or countries) where it was to be shown. Deserts, coasts, and cityscapes are all represented. The travel stops for international signage indicating dangers on the road ahead. As the journey comes to an end, the final sign instructs the audience "Not To Worry," dynamically transforming into a live tiger, Esso's symbol, to protect the road ahead.

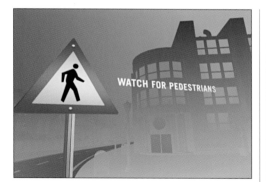

WATCH FOR PEDESTRIANS

WATCH YOUR ENGINE RUN SMOOTHLY

123 | 119 CHOICE
FORMAT: TELEVISION SPOT
CLIENT: VIRGINIA ENERGY COMMISSION

HOPEFUL

CHANGE IS WONDERFUL

CHOICE

Here, live action blends seamlessly with graphic transitions. The design moves the energy of the piece forward, warping and flowing between scenes and ultimately reconstructing to arrive at each new location. Aided by a cool jazz soundtrack, the commercial feels smooth, and the message singular.

DVD INTERFACE
TELEVISION SPOTS

124 | 120 DK PORTFOLIO
FORMAT: DVD INTERFACE
CLIENT: DIGITAL KITCHEN

125 | 120 I FLY

FORMAT: TELEVISION SPOT
CLIENT: INDIGO AIRLINES

The primary role of this commercial was to graphically illustrate the benefits of flying an elite, private business airline. In addition, the spotlighting of the airplane focuses attention on an impressive fleet of new, state-of-the-art jets.

126 | 120 DIVERSITY

FORMAT: TELEVISION SPOT
CLIENT: MICROSOFT

This is an unconventional design take on the "lemmings off the cliff" phenomenon. A cool graphic landscape looks fixed and clean—a perfect world—but it yields a surprising result as the population within plummets over an edge. The music stops and the typography speaks of the importance of diversity within the Microsoft Corporation.

Digital Kitchen

TELEVISION SPOT BRANDTHEATER
 EXCERPTS
TELEVISION SPOT

127 | 122 SCOOTER
FORMAT: TELEVISION SPOT BRANDTHEATER EXCERPTS
CLIENT: TARGET

128 | 122 CAR
FORMAT: TELEVISION SPOT BRANDTHEATER EXCERPTS
CLIENT: TARGET

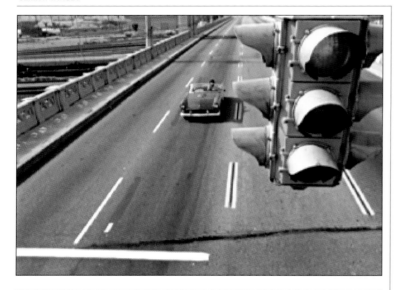

129 | 122 COFFEE
FORMAT: TELEVISION SPOT BRANDTHEATER EXCERPTS
CLIENT: TARGET

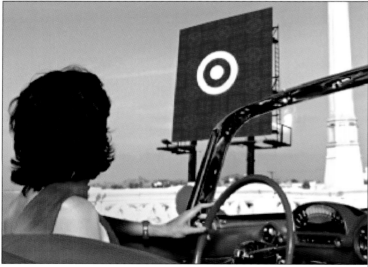

CAR, SCOOTER, COFFEE

DK developed 15 10-second bumpers for Target to use on a
corporate and broadcast level. Shot and animated by DK, the
cutty editing style allows rapid narrative jumps forward, aiding
storytelling. The graphics are designed to overtake the scene
in a surprising way, thereby cementing the Target brand.

130 | 123 PILOT, ANY PALM
FORMAT: TELEVISION SPOT
CLIENT: PALM

PILOT, ANY PALM

This spot focuses on three different Palm models with different demographics. Represented by different types of consumers, individuals were shot and then animated by DK, creating a unique and ownable look for Palm.

Digital Kitchen

TELEVISION SPOT
FORMAT: PROGRAM SEGUES

131 | 124 ORIGAMI
FORMAT: TELEVISION SPOT
CLIENT: QUIKRETE

ORIGAMI

The Quikrete commercial utilizes the only identifying asset that any concrete brand has—its bag. The idea was to use Quikrete's bright yellow paper bag for origami. Morphing into recognizable structures, the commercial builds over time, first concentrating on residential applications and later becoming bold enough to establish a cityscape for the viewer.

STAY TUNE'D

DK created a series of program segues for a television network. The theme "stay tune'd" plays on the focus of a music channel and invites the viewer to stay for a news brief, a programming schedule, or simply to stay for a while. The "u" and "n" of "tune'd" are constants that mark the identity of this series from spot to spot.

TITLE: STAY TUNE'D 1
FORMAT: STORYBOARD

TITLE: STAY TUNE'D 2
FORMAT: STORYBOARD

TITLE: STAY TUNE'D 3
FORMAT: STORYBOARD

Digital Kitchen

ART FILM

132 | 126 BRASIL: INSPIRED
FORMAT: ART FILM

DK's entry for the DVD accompanying the book *Brasil: Inspired*, published by Die Gestalten, gives the viewer a tour of a primitive/provocative side of Brazil. A narrator takes us on a journey that begins in a jungle-like, uncivilized setting, with McDonald's-branded cows, encounters with poisonous frogs and darts, and flesh-eating piranhas. We then emerge in an architecturally inspiring civilization.

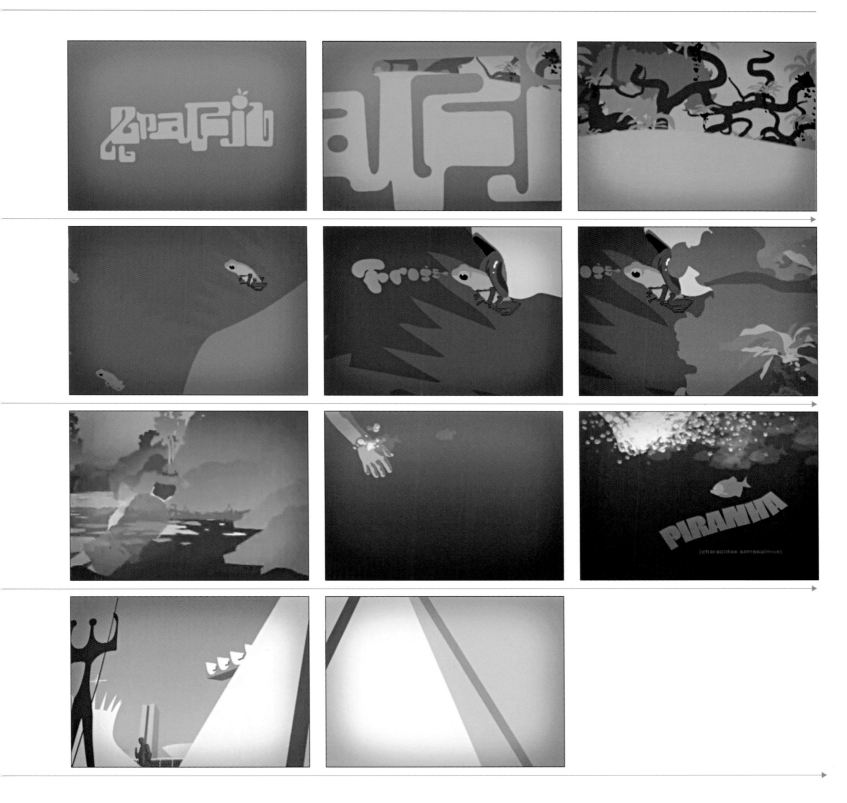

Digital Kitchen

ART FILM

BRASIL: INSPIRED, continued

The journey quickly moves into the civilized, but not less wild, Brazil—soccer championship games, beaches, Duran Duran, carnivals, thongs, to name just a few features. DK used brightly colored graphic illustrations set in parallax motion to create a 3-D space. Transitions quickly introduce environment after environment to saturate the viewer with the rich culture for which Brazil is known.

Motion Theory

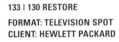

Motion Theory, a design and live-action production company based in Venice Beach, California, was cofounded in 2000 by Executive Producer Javier Jimenez and Creative Director Mathew Cullen. Utilizing design, live-action, and editorial techniques, the company designs, directs, and produces a variety of projects, striving to create memorable works that reach beyond simple function and form, and into emotion, connection, and understanding.

The creative team has garnered numerous awards from AIGA (American Institute of Graphic Arts), AICP (Association of Independent Commercial Producers), D&AD, and the Art Directors Club. Clients include Nike, Wieden + Kennedy, ESPN, Showtime Networks Inc., MTV, Saatchi & Saatchi, Toyota, Goodby, Silverstein & Partners, Hewlett Packard, Warner Bros., and DIRECTV.

133 | 130 RESTORE
FORMAT: TELEVISION SPOT
CLIENT: HEWLETT PACKARD

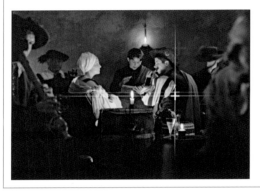
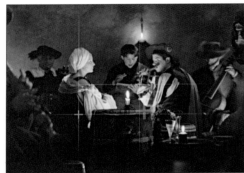
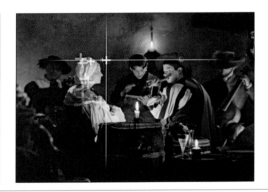

+hp CAMPAIGN: RESTORE/TOYS/NANOTECHNOLOGY/
US POSTAL SERVICE/DISNEY

Hewlett Packard and its agency Goodby, Silverstein & Partners asked Motion Theory to create the graphics for its first major advertising effort since its merger with Compaq in 2004. The campaign is based around the phrase "+hp," and shows how Hewlett Packard works with its customers to enable their businesses to run smoothly. In each commercial, the visual motif is a plus sign followed by the hp logo. Featured on these two pages are the motifs "Restore," "Toys," and "Nanotechnology." The following two pages feature the motifs "Disney," and "US Postal Service."

134 | 130 TECHNOLOGY (N IS FOR NANOTECHNOLOGY)
FORMAT: TELEVISION SPOT
CLIENT: HEWLETT PACKARD

135 | 131 TOYS (THE NEXT SHIFT)
FORMAT: TELEVISION SPOT
CLIENT: HEWLETT PACKARD

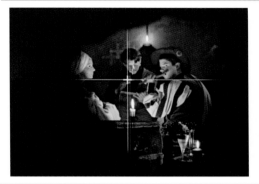

Motion Theory

TELEVISION SPOTS

136 | 132 US POSTAL SERVICE (IL POSTINO)
FORMAT: TELEVISION SPOT
CLIENT: HEWLETT PACKARD

137 | 132 DISNEY (ROCKET DELIVERY)

FORMAT: TELEVISION SPOT
CLIENT: HEWLETT PACKARD

+hp CAMPAIGN: ANTHEM

The "Anthem" spot of the "+hp" campaign first aired on
"Monday Night Football." The segment, "one day in the life of
technology," illustrates how Hewlett Packard helps many
major companies. In the FedEx segment, for example, we see
shots of packages moving along automated sorting machines,
each box accompanied by its own swarm of plus signs.

"We felt the concept needed to be fully linked with the
graphics, and we needed an elegant way to introduce the
'+hp' treatment into each scene," says Motion Theory lead
designer and Creative Director Mathew Cullen, who worked
on the campaign with Executive Producer Javier Jimenez and
Art Director Kaan Atilla.

"Our solution was to have the plus signs integrated
into the environments in which Hewlett Packard helps
its customers," adds Atilla.

138 | 132 ANTHEM
FORMAT: TELEVISION SPOT
CLIENT: HEWLETT PACKARD

Motion Theory

TELEVISION SPOTS

EVOLUTION

We know birds evolved from dinosaurs and humans from apes, but just how did skateboarders arise? "Evolution," an installment in ESPN's "Without Sports …" campaign, answers that question in less than 30 seconds, and simultaneously echoes the campaign's overall theme: the interconnectedness of sports and life.

"Evolution," the only "Without Sports …" spot to utilize 3-D animation, begins with an animated surfer riding a wave to the tune of the Jimi Hendrix classic "Ezy Rider." As the surfer cuts up the wave, his surfboard sprouts wheels, "evolving" into a skateboard. The surfer then becomes a skateboarder as the environment and animation style progress through the seventies, eighties, and nineties. After riding up the side of an empty pool, the skateboarder sails off the end of a modern-day half-pipe, spinning into the clouds and leaving with a memorable "Without Sports …" tag line.

Combining the spot's various animation styles and maintaining a constant sense of evolution required many planning and animation hours, a process that Motion Theory Creative Director Mathew Cullen describes simply as "Team, team, team, team, and team." Cullen was one of a team of 2-D animators that worked alongside an equally vital team of 3-D animators.

139 | 134 EVOLUTION
FORMAT: TELEVISION SPOT
CLIENT: ESPN

140 | 134 SHOCKEY
FORMAT: TELEVISION SPOT
CLIENT: FOX SPORTS TELEVISION

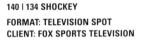
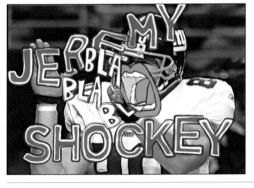

SHOCKEY

In an imaginative departure from the barrage of look-alike football spots, Foote Cone & Belding worked with Motion Theory and Brand New School to create an eye-catching new look for Fox Sports' NFL (National Football League) coverage commercials.

This collaboration between agency, client, and production houses produced five commercials that integrate live highlight footage, animation, graphics, and illustration, riveting the viewer's eyes to the larger-than-life personalities of the NFC.

"With virtually all the big stories in the [2003–2004] NFL season surrounding NFC [National Football Conference] teams and players, it just seemed natural that we find a way to package them all together with Fox, the network that brings you the NFC week in and week out," said Neal Tiles, Executive Vice President of Marketing for Fox Sports.

"We wanted to showcase what we felt were the great stories of the NFC," said Matt Reinhard, Senior Vice President and Creative Director at Foote Cone & Belding.

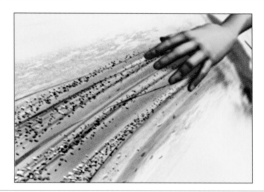

WITHOUT SPORTS,
EVOLUTION WOULD
JUST BE A THEORY

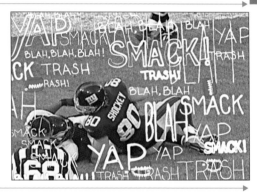

"Once we decided to tell these stories through highlight footage, we looked to partner with a group who could take highlights to another level. We found Motion Theory to be great collaborators in this project. With animation being the key ingredient, we were able to make the stories of the NFC come to life in a fresh and unexpected way."

Motion Theory

TELEVISION SPOTS

141 | 136 NIKE PRESTO: RIBBONS
FORMAT: TELEVISION SPOT
CLIENT: NIKE, INC.

PRESTO

Nike; Wieden + Kennedy, Tokyo; and Motion Theory came together to promote Nike's flagship Presto brand in over 12 Asian countries. The campaign was a follow-up to Motion Theory's successful execution of the 2002 Presto campaign. In 2003, they started with a simple idea: to put graffiti art in motion.

What they ended up with was four finished videos and a comprehensive print campaign—a combination of art, motion, and music that seeks to visualize how graffiti art might move if it could interact with music, culture, and the environment.

Part performance art, part commercial campaign, the works sought to communicate without words, across a variety of Asian cultures.

Each painted image inspired a moving vignette. Playful robots interact with geometric shapes and organic illustrations, all moving toward the goal of combining sound and form, and capturing the spirit of the art, landscape, and culture.

Motion Theory worked with cast and crew in Shanghai and Tokyo to film cityscapes that were emblematic of urban Asia.

Graffiti artist David Ellis (aka Skwerm), founder of New York–based Barnstormers artists' collective, handpicked artists Sasuke and Frek to collaborate with him on numerous works in Los Angeles. Motion Theory filmed the entire process.

The Motion Theory designers and animators combined the Shanghai and Tokyo scenes with elements from the paintings, as well as shots of the artists working on transparent Plexiglas canvases.

The finished works combine art and artist, process and result, metaphor and motion. This is all driven by electronic music created by Japanese DJ Uppercut, who makes an appearance in the videos as a colossal animated DJ spinning records on top of buildings, and generating sound through skyscraper-sized speakers.

142 | 136 NIKE PRESTO: INSTANTGO-ROOTZ
FORMAT: TELEVISION SPOT
CLIENT: NIKE, INC.

Motion Theory

TELEVISION SPOT
MUSIC VIDEO
FILM TEASER

143 | 138 NIKE FLOW (BASKETBALL ASIA)
FORMAT: TELEVISION SPOT
CLIENT: NIKE, INC.

FLOW

New York–based Korean graphic artist Romon Yang (aka Rostarr) lent a psychedelically designed hand to the live-action players in this commercial for Nike Asia. A basketball travels from player to player and into the basket, illustrating the concept of teamwork that spawned the idea of "Flow."

"In a typical US basketball commercial, there's usually a massive dunk and it's all about the individual play. Over discussions with the agency, we talked about Asian players not typically being 6ft 5in (c. 2m) and able to dunk, and the game being based on teamwork and passing. We moved away from individual highlights; capturing team spirit was really important," explains Motion Theory Director Grady Hall.

144 | 138 THE SCIENCE OF SELLING YOURSELF SHORT
FORMAT: MUSIC VIDEO
ARTIST: LESS THAN JAKE

THE SCIENCE OF SELLING YOURSELF SHORT

Shot on greenscreen, and incorporating live action with animation and 3-D environments, the band and its lead guitarist/vocalist Chris Neil appear in a variety of settings: a beach, a bar, a cityscape, and a hospital. At every turn, Neil's vices are there to haunt him.

Rather than the usual devil on the shoulder representing alter ego, animated legs, arms, and hands taunt and tempt Neil. They hold a drink, a deck of cards, and a cigarette, and follow the singer's every move. In a bar, a hand stretches out its index finger, like the head of a snake, and curls around Chris's head like a bandage, to transition into a scene in a hospital room.

Motion Theory worked with illustrator Florencia Zavala, who created the artwork for Less Than Jake's album "The Science of Selling Yourself Short," to create additional still images related to the lyrics. "We gave [the images] to our 3-D teams and put it into motion, like a bottle with legs, or a building with legs," describes Grady Hall, Motion Theory Art Director.

The process of integrating the animated components with live action of the band was difficult and time-consuming; every transition had to be planned prior to shooting. Still photos were taken on Venice Beach, California, to construct the illustrated 3-D environments.

With "Presto," featured on the previous pages, Motion Theory imposed a graphic world on top of a live-action spot. For "Flow," it placed live action within a graphic world. Most of the live footage was shot on greenscreen. After reviewing videos of John Wooden and Princeton Offense to identify great plays, the choreography was previsualized in 3-D. The set was green: a 50 x 200ft (c. 15 x 61m) greenscreen, a green full-size pro course and basket, and even a green basketball. This was preparation for the design treatment, which required multiple layers in the video-effects software. These layers allowed Motion Theory's 3-D designers to bring Rostarr's work, which is primarily 2-D, into the dimensions of space and time.

145 | 139 THE KILLING YARD
FORMAT: FILM TEASER
CLIENT: SHOWTIME NETWORKS

THE KILLING YARD

Showtime recruited Motion Theory to design, shoot, and produce a 30-second teaser and graphics package for the movie *The Killing Yard*. Subtle, dramatic graphics and precise sound design capture the action-packed story line of Showtime's original courtroom drama. *The Killing Yard* tells the story of the Attica prison riots through a series of flashbacks, as related by inmates being held on trial for murder at the time.

Remaining consistent with the style and theme of the movie, the teaser utilizes the contradiction between the harsh images of barbed wire and the delicate movements of a floating feather. This juxtaposition signifies the differences in perspective given by each side in the courtroom battle.

Motion Theory worked closely with the clients to create the graphics elements, character IDs, and title. They chose to shoot the design elements and the typography on a 35mm camera, while capturing high-speed shots for the footage of the barbed wire and falling feather. The entire teaser is presented in black and white in order to remain consistent with the grittiness of the flashback scenes within the movie. Because the spot is reliant on type to tell the story, the sound design is its driving force. There is no voice-over. Rather, helicopters, gunshots, wind, screams, and sounds from the dramatic flashbacks allude to the intensity of the drama. The simple and subtly symbolic images, coupled with the

powerful sound design and dramatic typography, brings the viewer to the point of the movie's climax in order to provoke an emotional response.

Motion Theory

FILM TEASER
MUSIC VIDEO

146 | 140 SOLDIER'S GIRL
FORMAT: FILM TEASER
CLIENT: SHOWTIME NETWORKS

SOLDIER'S GIRL

Set in Fort Campbell, Kentucky, *Soldier's Girl* is the true story of the life and tragic death of soldier Barry Winchell. His love for Calpernia Addams, a beautiful, transgendered nightclub performer, was misunderstood by fellow soldiers and eventually led to his brutal death. MT created a teaser for the film that uses live-action footage of a close-up hand and a dogtag and chain. The sequence opens with the hand gently holding and caressing the chain. The phrase, "she was the only" fades in over the top of this footage and then individual letters fall away to transform "she" into "he." The word "love" emerges over the top of the dogtag chain transitioning into a string of pearls.

147 | 141 ANIMAL
FORMAT: MUSIC VIDEO
ARTIST: R.E.M.

ANIMAL

The video for R.E.M.'s "Animal" is a synthesis of live action, 3-D animation, in-camera, and postproduction transitions. The video opens with images of stars and constellations. Frontman Michael Stipe enters a dark, urban landscape that is part industrial science fiction, part nature. Stipe paces in the shadowy environment of steel stairs, elevated walkways, and in a caged elevator, as if he were a trapped animal.

He reaches the rooftop, where he touches the surface and absorbs a spark of energy that allows him to see the world in a way never before possible. The setting reveals a couple kissing, people fighting, and a man reaching out for something, all cocooned in their own energy field. Posing on the edge of the roof, as the moon eclipses the sun, Stipe is propelled into space. In the final moments of the video, the eclipse breaks apart, with the moon arcing over Stipe and revealing the sun behind it, bringing the video full circle.

M+Motive

PRODUCT PRESENTATION FILMS

In 2000, Creative Director and Principal Joel Markus and his design firm, M, Inc., partnered up with Design and Effects Director Robert Hoffmann and his firm, Motive. The result is a multidisciplinary design and effects consortium that specializes in creative direction, design, and production for regional, national, and international clients. The team is committed to providing innovative, quality conceptual design that withstands trends in the marketplace. They invite their clients into a collaborative exchange in order to carefully formulate an appropriate solution to fit needs

and goals. A particular strength of the team approach of M+Motive is to put together the best suitable team to execute a project that is an optimal fit for a client's specific needs. M+Motive are dedicated to developing long-term relationships with clients. The teams have garnered national and international recognition through their design for The Learning Channel, Discovery Channel USA and International, Home and Garden Channel, and ESPN International, and also for regional television networks.

148 | 142 SURROUND SOUND
FORMAT: PRODUCT PRESENTATION FILM
CLIENT: BOSE CORPORATION , BUZ LAUGHLIN, JESSE FLACK

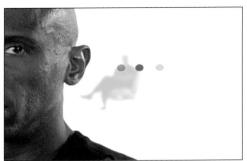

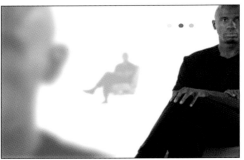

SURROUND SOUND, BASS, AND SIGNAL PROCESSING

This series of three 45–60-second spots for Bose aims to demonstrate the renowned audio company's unique technology in an in-car environment. Three characteristics are presented: surround sound, bass, and signal processing. Presentation of these spots was to a selected audience, so the message needed to be conveyed simplistically, in a limited amount of time. M+Motive achieved this in part by designing through the lens of the camera, which allowed for visual interactivity between live-action talent and graphics, as well as overall composition of the scenes.

149 | 143 BASS

FORMAT: PRODUCT PRESENTATION FILM
CLIENT: BOSE CORPORATION, BUZ LAUGHLIN

150 | 143 SIGNAL PROCESSING

FORMAT: PRODUCT PRESENTATION FILM
CLIENT: BOSE CORPORATION, BUZ LAUGHLIN

PRODUCT PRESENTATION FILM

PASSION MEETS RESEARCH

This spot is a 2:30-minute presentation for the viewer to experience Bose's in-car audio systems. M+Motive created a collage of images from stills, film, and video, mixed with typographic expression to enhance the musical segments. The piece was designed to increase in energy as it progressed. A blizzard of treated images and type was key in making 2:30 minutes seem to go by fast, leaving the viewer wanting more.

Shown on this page are two components developed in the planning of the final presentation on the facing page. The timeline below helped the creative team plan for specific activities—visual and audio—to occur and interact at specific points during the 2:30-minute timeframe. The storyboard frames on the right offer a sketch of the presentation without consideration of the timeframe. These planning devices present a clear idea for the client to understand the overall visual language, content, pace, and rhythm.

STORYBOARD FRAMES

PASSION MEETS RESEARCH: ROUGH TIMELINE

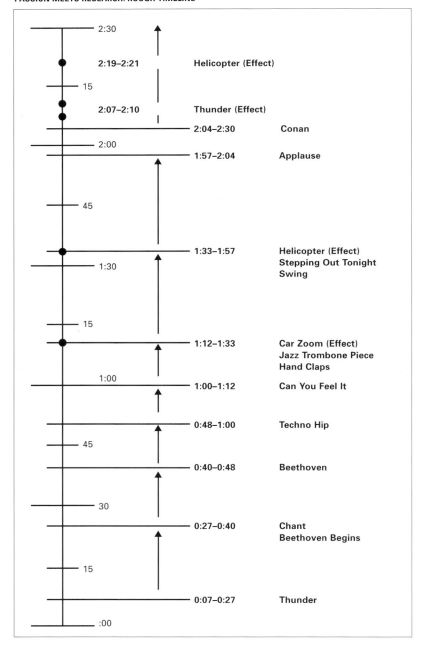

- 2:30
- 2:19–2:21 — Helicopter (Effect)
- 15
- 2:07–2:10 — Thunder (Effect)
- 2:04–2:30 — Conan
- 2:00
- 1:57–2:04 — Applause
- 45
- 1:33–1:57 — Helicopter (Effect) / Stepping Out Tonight / Swing
- 1:30
- 15
- 1:12–1:33 — Car Zoom (Effect) / Jazz Trombone Piece / Hand Claps
- 1:00 — 1:00–1:12 — Can You Feel It
- 0:48–1:00 — Techno Hip
- 45
- 0:40–0:48 — Beethoven
- 30
- 0:27–0:40 — Chant / Beethoven Begins
- 15
- 0:07–0:27 — Thunder
- :00

151 | 145 PASSION MEETS RESEARCH
FORMAT: PRODUCT PRESENTATION FILM
CLIENT: BOSE CORPORATION, BUZ LAUGHLIN

M+Motive

PROGRAM IDENTITIES

152 | 146 BIKE WEEKEND

FORMAT: PROGRAM IDENTITY
CLIENT: DISCOVERY CHANNEL, JEFF STRONG,
HEATHER ROYMANS

153 | 146 WELD OF THE WEEK

FORMAT: PROGRAM IDENTITY
CLIENT: DISCOVERY CHANNEL, JEFF STRONG

BIKE WEEKEND

The Discovery Channel was in need of a promotional campaign for its program *Bike Weekend*. The first challenge for M+Motive was to design the title treatment in storyboard format. The next step was to capture raw footage in both mini digital video and digital still images: a biker wearing a leather jacket, and various parts of a motorcycle.

In building the motion sequence, M+Motive implemented the *Bike Weekend* title design onto the gas tank of the cycle. For this, M+Motive used a wide shot from a selected raw clip, then applied a pop zoom tight shot of a still image of the cycle's gas tank with the imposed title design. Added effects and atmosphere strengthen the illusion.

For the live action, M+Motive shot the biker in an alley turning around to show the back of his leather jacket. They added the Discovery logo to the back of the jacket electronically with a tracking method so the logo follows the back of the jacket as it turns toward the camera. A layered still of the cycle's mirror on the handlebars allowed M+Motive to apply a motion clip of a motorcycle passing by. Finishing touches include atmosphere to give a stronger sense of reality.

The entire promotional package consisted of elements such as promo opens, promo tags, transitions, tune-ins, and network identity.

WELD OF THE WEEK

This Discovery Channel Identity (5 seconds) presents a close-up shot of a welder pulling his eye shield down and revealing the animated Discovery Logo. M+Motive captured a tight shot of the welder pulling his shield down and added the Discovery logo through a tracking technique. Smoke was layered into the composition.

154 | 147 REAL INTELLIGENCE: THE SECRET OF SPYING
FORMAT: PROGRAM IDENTITY
CLIENT: DISCOVERY CHANNEL, JEFF STRONG, KEITH JODOIN

REAL INTELLIGENCE: THE SECRETS OF SPYING

This 5-second title sequence begins with a jittering fingerprint. This image then enlarges to reveal that it is composed of computer data. The typographic pun of the spy walking and serving as a letter "i," together with the sound of the letter connoting the "eye" that is watching us, completes this high-energy sequence.

M+Motive

155 | 148 MONSTER GARAGE
FORMAT: PROGRAM IDENTITY
CLIENT: DISCOVERY CHANNEL, DAN STANTON, JEFF STRONG

M+Motive were asked to design a promotional graphic package for the premiere of *Monster Garage* on the Discovery Channel. The first phase of the project was to create a title design. This process evolved in several stages. The program logo had to be applied to various formats, including T-shirts, hats, a hot-air balloon, and a jumbotron screen. Once the title mark was designed, M+Motive used it in the on-air package. These elements consisted of a promo opening and closing, transitions, treatment for tune-in information, and Discovery identification. The studio produced several of these elements from high-resolution stills that they shot, then composed them with special effects; for example, the metal garage door and the brick wall.

LOGO CONCEPTS

PRESENTATION A

PRESENTATION B

PRESENTATION C

PRESENTATION D

FINAL

156 | 149 DISCOVERY GOES TO THE MOVIES
FORMAT: PROGRAM IDENTITY
CLIENT: DISCOVERY CHANNEL, JEFF STRONG,
ALBERTO ENRIQUEZ

DISCOVERY GOES TO THE MOVIES

The approach of M+Motive in this project was to present a
film clapboard spinning to reveal messages simultaneously.
The Discovery logo on one side and "Discovery Goes To The
Movies" on the other side were designed as panels, then
applied to the clapboard. M+Motive rigged the clapboard so
that an electric drill could spin it in opposite directions and at
different speeds. The team then captured the spinning prop
from several angles and zooms with their mini digital video
camera. This footage became the base layer in composing
images and effects for the final sequence.

M+Motive

PROGRAM IDENTITIES
NETWORK GREETING

157 | 150 PLAY LIKE THE PROS
FORMAT: PROGRAM IDENTITY
CLIENT: ESPN

158 | 150 NFL ON ESPN
FORMAT: PROGRAM IDENTITY
CLIENT: ESPN INTERNATIONAL, ANDY BRONSTEIN,
LARRY ROSEN

159 | 150 ESPN SALUTES
FORMAT: NETWORK GREETING
CLIENT: ESPN INTERNATIONAL, ANDY BRONSTEIN

PLAY LIKE THE PROS

In this simple spot, an image of a golf ball containing the ESPN logo is knocked off its "tee" along with all the characters in the title, *Play Like The Pros*.

NFL ON ESPN

To promote ESPN's airing of NFL games internationally, M+Motive used a coach's playbook of diagrams, revealed in various levels of opacity, as a backdrop to the title sequence. The layering at different scales and sequences of plays, mixed with live footage, suited the hard-driving nature of the sport.

ESPN SALUTES

M+Motive produced a holiday package for ESPN International to represent peace, in the shadow of the 9/11 attacks. A flame representing eternity morphs into the ESPN logo. The word "peace" appears in different languages. The candle was shot with a mini digital video camera and manipulated with software to transform the flame into the ESPN logo.

160 | 151 FÚTBOLDE ITALIA
FORMAT: PROGRAM IDENTITY
CLIENT: ESPN INTERNATIONAL, ANDY BRONSTEIN, GUSTAVO GRANADOS

FÚTBOLDE ITALIA (ITALIAN SOCCER ON ESPN INTERNATIONAL)

Soccer (football) is a very popular sport on ESPN International. The producers at ESPN needed a title treatment along with opens and tags for promotional spots, presented in multiple languages. M+Motive decided to stylize elements of the sport and use the colors of the Italian flag as their starting point. Shots of a foot kicking, hands blocking, a jersey, and a goal net were their main visuals. Contrasting these images into black-and-white and then coloring them worked well for transitioning from sequence to sequence. The title treatment was abstractly translated from soccer ball designs.

PSYOP

111 | 106 AT&T BROADBAND
FORMAT: TELEVISION SPOTS
CLIENT: AT&T BROADBAND

Production Company: PSYOP
Directors: Kylie Matulick and Todd Mueller with V12
 Creative Director Juan Delcan
Designers: Kylie Matulick with V12 Creative Director
 Juan Delcan
Technical Director: Marco Spier
Compositing: Eben Mears
Modelers/Animators: Todd Akita, Marko Vukovic

112 | 108 COME FOR BRAZIL
FORMAT: ART FILM
CLIENT: DIE GESTALTEN

Production: PSYOP
Directors: Marie Hyon, Todd Mueller, Kylie Matulick
Designers: Marie Hyon, Todd Mueller, Kylie Matulick,
 Daniel Piwowarczyk
Executive Producer: Justin Booth-Clibborn
Producer: Gregory B. Edwards
Technical Director: Todd Akita
Compositing: Kylie Matulick
Modelers/Animators: Todd Akita, Daniel Piwowarczyk,
 Ilan Katin
Special Thanks: Die Gestalten Verlag Publications

113 | 109 DRIFT
FORMAT: ART FILM
CLIENT: BOMBAY SAPPHIRE

Agency: Margeotes Fertitta + Partners

Creative Director: Fritz Westenberger
Executive Producer: Annette Suarez
Producer: Meagan MacDonald

Production: PSYOP
Design/Animation: PSYOP
Designer/Director: Todd Mueller
Designer/Director: Kylie Matulick
Executive Producer: Justin Booth-Clibborn
Producer: Daniel Rosenbloom
Technical Director/Development: Todd Akita
Flame Artist/Composite: Eben Mears
Flame Artist/Composite: Roi Werner
Animation Artists: Todd Akita, John Clausing, Tom Cushwa,
 Kevin Estey, Eric Borzi, Kent Seki
Titles Design: Jim Forster
Audio/Music Production/Sound Design: Singing Serpent
Composer: Rafter Roberts
Film Remix: Kenseth Thibideau

114 | 110 FORTUNE FADED
FORMAT: MUSIC VIDEO
ARTIST: RED HOT CHILI PEPPERS

Director: Laurent Briet
Producer: Michele Abbott
Director of Photography: Chris Soos
Editor: Richard Cooperman

PSYOP Credits:
Visual Effects Supervisor/Senior Flame Artist: Eben Mears
Visual Effects Supervisor/Animation Director: Marco Spier
Technical Director: Pakorn Bupphavesa
Executive Producer: Justin Booth-Clibborn
Producer: Doron Tadmor

Creative Director: Marie Hyon
Illustrator: Duncan Jago
Flame Artist: Aska Otake
Designers: Haejin Cho, Daniel Piwowarczyk, Pal Moore
Animators: Domel Libid, Christian Bach, Joerg Liebold,
 Gerald Ding, Alvin Bae, Kevin Estey

115 | 112 THE BLOCK
FORMAT: PROGRAM TEASER
CLIENT: ESPN

Production: PSYOP
Directors: Marie Hyon, Marco Spier
Designer: Marie Hyon
Flame Artist/Composite: Eben Mears
Producer: Angela Bowen
Technical Director: Marco Spier
Modelers/Animators: Marco Vukovic, Pakorn Bupphavesa,
 Domel Libid, Jason Goodman, Jason Strugo, Joel
 Sevilla, Jeremy Butler, Chad Ferron

116 | 113 DARKNESS ACCELERATES
FORMAT: TELEVISION SPOT
CLIENT: FOX SPORTS TELEVISION

Production: PSYOP
Directors: Marie Hyon, Marco Spier
Executive Producer: Justin Booth-Clibborn
Producer: Danny Rosenbloom
Design: Marie Hyon
Associate Producer: Joe Hobaica
Flame Artist/Composite: Eben Mears
Technical Directors: Todd Akita, Pakorn Bupphavesa,
 Marko Vukovic
Animation: Laurent Barthelemy, Alvin Bae, Kevin Estey,
 Eric Lampi, Domel Libid
Editing: Jed Boyar, Chris Gereg
Additional Rotoscope Support: Joe Vitale

Fox Credits:
Creative Director: Mark Denyer-Simmons
Senior Vice President On-Air Promotions, Creative Director
 Fox Sports Television Group: Scott Bantle
Executive Vice President of Marketing Fox Sports Television
 Group: Neal Tiles
Sound Design: Mick Brooling

117 | 114 ARROW
FORMAT: TELEVISION SPOT
CLIENT: LUGZ FOOTWEAR

Agency: Avrett Free & Ginsberg

Agency Credits:
Creative Director: Rory Braunstein
Producer: Karen Fazekas
Account Supervisor: Mitch Krevat

Other Credits:
Production: PSYOP
Director: Marie Hyon, Marco Spier, Todd Mueller
Executive Producer: Justin Booth-Clibborn
Director of Photography: Patrick Cady
Producer: Daniel Rosenbloom
Visual Effects: PSYOP
Artists: Eben Mears (Flame Artist), Andy Hara (3-D Support
Artist), Marion Ennis (2-D Support Artist)
Other (3-D R&D): Todd Akita
Audio Mixer: DJ Funkmaster Flex & Joe Vagnoni Photomag

118 | 115 MY MUSIC AWARDS
FORMAT: PROGRAM CATEGORY BUMPERS
CLIENT: VH1

Design/Visual Effects/Animation: PSYOP
Directors: Marie Hyon, Marco Spier
Special Effects Director: Eben Mears
Producer: Kimmy Ng
Executive Producer: Justin Booth-Clibborn
Creative Consultant/Writer: Steve Raymond
Creative Consultant: Todd Mueller
Animators: Marco Vukovic, Pakorn Bupphavesa, Todd Akita,
 Kent Seki, Jason Goodman, Domel Libid, Joel Sevilla,
 Jeremy Butler, Danny Selinger, Collin Barton

VH1 Credits:
Creative Director: Susan Kantor

119 | 116 DNA
FORMAT: TELEVISION SPOT
CLIENT: VOLKSWAGEN

Production: PSYOP
Directors/Designers: Marie Hyon, Kylie Matulick, Todd Mueller
Head of 3-D Animation: Marco Spier
Flame Artist/Composite: Eben Mears
Executive Producer: Justin Booth-Clibborn
Technical Directors: Todd Akita, Pakorn Bupphavesa
Animator/Assistant Technical Director: Domel Libid
Animators: Marko Vukovic, Joel Sevilla, Jeremy Butler,
 Jason Goodman
Camera Animators: Sean Eno, Kent Seki, Chris Batty
Modelers: Tom Cushwa, Jason Strougo, Gavin Guerra

120 | 117 PSYOP ANTHEM
FORMAT: SHORT FILM
CLIENT: PSYOP

Directors: Todd Mueller, Kylie Matulick
Designers: Todd Mueller, Kylie Matulick, Justin Fines,
 Heajin Cho, Pal Moore, Daniel Piwowarczyk, Marie Hyon
Executive Producer: Justin Booth-Clibborn
Producer: Joe Hobaica
Technical Directors: Todd Akita, Marko Vukovic
Modeling/Animation: Alvin Bae, Christian Bach, Gerald Ding,
 Kevin Estey, Domel Libid, John Wade Payne
3-D Modeling: Tom Cushwa, Todd Akita, Alvin Bae
Particle Effects: Eric Lampi
Compositor: Aska Otake
Lyrics: Steve Raymond
Music/Music Production/Synths/Drum Programming: Jed
 Boyar
Audio Engineering/Live Drums/Live Guitars: Joel Hamilton at
 Studio G
Brooklyn Bass/additional Music Production: Tony Maimone
Piano: the Reverend Vince Anderson
Vocals: Dave Driver
Kid Voices: Thomas Ashton, Thomas Hourigan, Henry
 Rosenbloom, Molly Rosenbloom
Special thanks to Cat Oberg

DIGITAL KITCHEN (DK)

121 | 118 THE BEST WE GOT, FRIDAYS
FORMAT: NETWORK PROGRAM IDENTITY BRAND PACKAGE
CLIENT: CARTOON NETWORK

Design: DK
Motion Graphics: DK
Editorial: DK

122 | 118 DO NOT, WATCH, ZONES
FORMAT: TELEVISION SPOT
CLIENT: ESSO

Agency: McCann-Erickson NY
Production: DK
Design: DK
Director: DK
Motion Graphics: DK
Editorial: DK

123 | 119 CHOICE
FORMAT: TELEVISION SPOT
CLIENT: VIRGINIA ENERGY COMMISSION

Agency: Fitzgerald & Co.
Production company: DK
Design: DK
Director: DK
Motion Graphics: DK
Editorial: DK
Music Production: DK
Music Performance: Anthony Marinelli, Music Forever

124 | 120 DK PORTFOLIO
FORMAT: DVD INTERFACE
CLIENT: DIGITAL KITCHEN

Design: DK
Production: DK

125 | 120 I FLY
FORMAT: TELEVISION SPOT
CLIENT: INDIGO AIRLINES

Agency: Blue Elephant
Production Company: DK
Design: DK
Director: DK
Motion Graphics: DK
Editorial: DK
Music: DK

126 | 120 DIVERSITY
FORMAT: TELEVISION SPOT
CLIENT: MICROSOFT

Agency: McCann-Erickson
Design: DK
Motion Graphics: DK
Editorial: DK
Music: DK

127 | 122 SCOOTER
128 | 122 CAR
129 | 122 COFFEE
FORMAT: TELEVISION SPOT BRANDTHEATER EXCERPTS
CLIENT: TARGET

Agency: Little & Co.
Production: DK
Design: DK
Director: DK
Motion Graphics: DK
Editorial: DK

130 | 123 PILOT, ANY PALM
FORMAT: TELEVISION SPOT
CLIENT: PALM

Agency: AQKA
Production Company: DK
Design: DK
Director: DK
Motion Graphics: DK
Editorial: DK

131 | 124 ORIGAMI
FORMAT: TELEVISION SPOT
CLIENT: QUIKRETE

Agency: Fitzgerald & Co.
Production Company: DK
Design: DK
Director: DK
Motion Graphics: DK
Editorial: DK
Music Production: DK
Music Performance: Mark Walk/IWI Productions

STAY TUNE'D 1
STAY TUNE'D 2
STAY TUNE'D 3
FORMAT: PROGRAM SEGUE

Design: DK
Motion Graphics: DK
Editorial: DK
Music: DK

132 | 126 BRASIL INSPIRED
FORMAT: ART FILM
CLIENT: DIE GESTALTEN

Design: DK
Motion Graphics: DK
Editorial: DK
Music: DK

MOTION THEORY

133 | 130 RESTORE
FORMAT: TELEVISION SPOT
CLIENT: HEWLETT PACKARD

Agency Credits:
Agency: Goodby, Silverstein & Partners
Creative Directors: Steve Luker, Steve Simpson
Art Director: Paul Foulkes
Copywriter: Diane Hill
Executive Producer: Elizabeth O'Toole

Director Credits:
Director: Rupert Sanders

Creative/Design Credits:
Design Company: Motion Theory
Creative Director: Mathew Cullen
Art Director: Kaan Atilla
Designers: Kaan Atilla, Mark Kudsi
Executive Producer: Javier Jimenez

Production Credits:
Production Company: Omaha Pictures
Director of Photography: Jess Hall

Executive Producer: Eric Stern
Producer: Paul McPadden

Other Credits:
Editorial Company: The Whitehouse
Editor: Neil Smith
Visual Effects Company: A52

134 | 130 TECHNOLOGY (N IS FOR NANOTECHNOLOGY)
FORMAT: TELEVISION SPOT
CLIENT: HEWLETT PACKARD

Agency Credits:
Agency: Goodby, Silverstein & Partners
Creative Director: Steve Simpson
Associate Creative Director: John Norman
Group Creative Director: Steve Luker
Copywriter: Matt Ashworth
Producer: Lisa Gatto

Director Credits:
Director: Geoff McFetridge

Creative/Design Credits:
Design Company: Motion Theory
Creative Director: Mathew Cullen
Designer: Paulo de Almada
Executive Producer: Javier Jimenez

Production Credits:
Production Company: The Directors Bureau (HKM)
Director of Photography: Yon Thomas

Other Credits:
Editorial Company: The Directors Bureau (HKM)

135 | 131 TOYS (THE NEXT SHIFT)
FORMAT: TELEVISION SPOT
CLIENT: HEWLETT PACKARD

Agency Credits:
Agency: Goodby, Silverstein & Partners
Creative Directors: John Norman, Rich Silverstein,
 Steve Simpson
Art Directors: Todd Grant, John Norman
Copywriter: John Knecht
Producer: Colleen Wellman
Executive Producer: Elizabeth O'Toole

Director Credits:
Director: Frank Budgen

Creative/Design Credits:
Design Company: Motion Theory
Creative Director: Matthew Cullen
Designers: Tom Bruno, Paulo de Almada
Executive Producer: Javier Jimenez

Production Credits:
Production Company: Gorgeous Enterprises/
 Anonymous Content
Director of Photography: Harris Savides

Other Credits:
Editorial Company: Final Cut
Editor: Kirk Baxter
Visual Effects: A52
Music Company: Agoraphone

136 | 132 POSTAL SERVICE (IL POSTINO)
FORMAT: TELEVISION SPOT
CLIENT: HEWLETT PACKARD

Agency Credits:
Agency: Goodby, Silverstein & Partners
Creative Director: Steve Luker

Producer: Colleen Wellman

Director Credits:
Director: Fredrik Bond

Creative/Design Credits:
Design Company: Motion Theory
Creative Director: Matthew Cullen
Art Director: Paulo de Almada
Visual FX Supervisor: John Clark
Designers: Kaan Atilla, Tom Bruno, Mark Kudsi, Irene Park,
 Shihlin Wu
Executive Producer: Javier Jimenez

Production Credits:
Production Company: Morton Jankel Zander (MJZ)

Other Credits:
Editorial Company: Lost Planet
Editor: Hank Corwin
Visual Effects: Method

137 | 132 DISNEY (ROCKET DELIVERY)
FORMAT: TELEVISION SPOT
CLIENT: HEWLETT PACKARD

Agency Credits:
Agency: Goodby, Silverstein & Partners
Creative Directors: Steve Simpson, Steve Luker
Art Director: Steve Yee
Copywriter: Dan Rollman
Producer: Adrienne Cummins

Director Credits:
Director: Jake Scott

Creative/Design Credits:
Design Company: Motion Theory
Creative Director: Mathew Cullen
Designers: Paulo de Almada, Mark Kudsi
Executive Producer: Javier Jimenez

Production Credits:
Production Company: RSA Films
Director of Photography: Chris Soos
Producer: David Mitchell

Other Credits:
Editorial Company: Lost Planet
Editor: Hank Corwin
Visual Effects: A52

138 | 132 ANTHEM
FORMAT: TELEVISION SPOTS
CLIENT: HEWLETT PACKARD

Agency Credits:
Agency: Goodby, Silverstein & Partners
Creative Directors: Steve Luker, John Norman, Steve Simpson
Producer: Adrienne Cummins

Director Credits:
Director: Ralf Schmerberg

Creative/Design Credits:
Design Company: Motion Theory
Creative Director: Matthew Cullen
Art Director: Kaan Atilla
Designers: Jason Cook, Paulo de Almada, Irene Park,
 Mike Slane, John Clark, Michael Steinman
Executive Producer: Javier Jimenez

Production Credits:
Production Company: @radical media, Los Angeles
Director of Photography: Darius Konji

Other Credits:
Editorial Company: Lost Planet
Editor: Hank Corwin
Assistant Editor: Jennifer Dean

139 | 134 EVOLUTION
FORMAT: TELEVISION SPOT
CLIENT: ESPN

Agency Credits:
Agency: Weiden + Kennedy, NY
Art Director: Kim Schoen
Creative Director: Ty Montague, Todd Waterbury
Agency Copywriter: Kevin Proudfoot
Agency Producer: Brian Cooper
Agency Executive Producer: Gary Krieg

Director Credits:
Director: Motion Theory

Creative/Design Credits:
Creative Director: Mathew Cullen
Designers: Mathew Cullen, Kaan Atilla, Jesus De Francisco
3-D animators: John Clark, Paulo De Almada, Tom Bradley,
 Tom Bruno, Ryan Alexander, Chris De St. Jeor

Production Credits:
Production Company: Motion Theory
Executive Producer: Javier Jimenez

140 | 134 SHOCKEY
FORMAT: TELEVISION SPOT
CLIENT: FOX SPORTS TELEVISION

Agency Credits:
Agency: Foote Cone & Belding
Creative Directors: Matt Reinhard, Brian Bacino
Art Director: Matt Reinhard
Copywriter: Paul Carek
Producer: Steve Neely, Vince Genovese
Account Lead: Micheal Chamberlin
Editorial: FCB in-house
Editors: Matt Konachek, Dave Becker, John Buscalgia

Director Credits:
Director: Motion Theory

Creative/Design Credits:
Creative Directors: Mathew Cullen, Grady Hall
Art Director: Jesus De Francisco
Designers/Animators: Jesus De Francisco, Mathew Cullen,
 Tom Bradley, Chris De St. Jeor, Tom Bruno, Linas
 Jodwalis, Mike Steinmann, Brad Watanabe
Illustrator: Cam Goode

Production Credits:
Production Company: Motion Theory
Executive Producer: Javier Jimenez

141 | 136 NIKE PRESTO: RIBBONS
142 | 136 NIKE PRESTO: INSTANTGOROOTZ
FORMAT: TELEVISION SPOTS
CLIENT: NIKE, INC.

Agency Credits:
Agency: Wieden + Kennedy, Tokyo
Creative Directors: John C. Jay, Sumiko Sato
Art Director: Eric Cruz
Copywriter: Barton Corley
Agency Producer: Kenji Tanaka
Account Executive: Fumiko Horiuchi

Director Credits:
Director: Motion Theory
Director of Photography: Roman Jakobi

Creative/Design Credits:
Designers: Mathew Cullen, Kaan Atilla, Irene Park,
 Ryan Alexander, Paulo De Almada, John Clar, Tom
 Bruno, Tom Bradley, Bridget Mckahan, Chris De St. Jeor
Artistic Director (graffiti): David Ellis
Graffitti Artists: Skwerm, Sasu, Frek

Production Credits:
Production Company: Motion Theory
Executive Producer: Javier Jimenez

Other Credits:
Editors: Mark Hoffman, Jutta Reichardt
Music Composer: Dj Uppercut
Music Producer: Bruce Ikeda

143 | 138 NIKE FLOW (BASKETBALL ASIA)
FORMAT: TELEVISION SPOT
CLIENT: NIKE, INC.

Agency Credits:
Agency: Wieden + Kennedy, Tokyo
Creative Director: John C. Jay, Sumiko Sato
Art Directors: Eric Cruz, John C. Jay
Copywriter: Sumiko Sato
Producers: Kenji Tanaka, Cherie Appleby
Account Executive: Anthony Matsuo

Director Credits:
Live Action Director: Motion Theory, John Schwartzman (RSA)
Director of Photography: John Schwartzman

Creative/Design Credits:
Creative Directors: Mathew Cullen, Grady Hall
Designers: Kaan Atilla, Mathew Cullen, Mark Kudsi, Irene
 Park, Mike Siane, Mike Steinmann, Brad Watanabe,
 Shihlin Wu
3-D Animators: Ryan Alexander, Paulo De Almada, Tom
 Bradley, Tom Bruno, Chris De St. Jeor, John Clark,
 Bonnie Rosenstein

Production Credits:
Production Companies: RSA, Motion Theory
Executive Producers: Margie Abrahams (RSA), Javier Jimenez
 (Motion Theory)

Other Credits:
Campaign Artist: Rostarr
Editor: J. D. Smyth (Rock Paper Scissors)
Music: Jurassic 5

144 | 138 THE SCIENCE OF SELLING YOURSELF SHORT
FORMAT: MUSIC VIDEO
ARTIST: LESS THAN JAKE
CLIENT: WARNER BROS. RECORDS

Client Credits:
Warner Bros. Video Commissioner: Devin Sarno

Director Credits:
Director: Motion Theory
Director of Photography: David Morrison

Creative/Design Credits:
Creative Directors: Mathew Cullen, Grady Hall

Designers: Jesus De Francisco, Kaan Atilla, Irene Park,
 Mark Kudsi, Mike Slane
3-D Animators: Tom Bradley, Tom Bruno, John Clark, Paulo
 De Almada, Linas Jodwalis, Chris De St. Jeor
Illustrators: Florecio Zavala, Martha Rich

Production Credits:
Production Company: Motion Theory
Executive Producer: Javier Jimenez
Producer: Bo Platt

145 | 139 THE KILLING YARD

FORMAT: FILM TEASER
CLIENT: SHOWTIME NETWORKS

Client Credits:
Creative Director: Paula Mermelstein
Art Director: Christina Black
Producer: Erik Friedman

Director Credits:
Director: Motion Theory

Creative/Design Credits:
Creative Director: Mathew Cullen

Production Credits:
Production Company: Motion Theory
Executive Producer: Javier Jimenez

Other Credits:
Editor: Mark Hoffman
Illustrator: Cam Goode
Copywriter: Liza Bernstein
Sound Designer: Pete Kneser

146 | 140 SOLDIER'S GIRL

FORMAT: FILM TEASER
CLIENT: SHOWTIME NETWORKS

Client Credits:
Creative Director: Paula Mermelstein
Art Director: Christina Black
Producer: Erik Friedman

Director Credits:
Director: Motion Theory
Director of Photography: Scott Galinsky

Creative/Design Credits:
Art Director/Designer: Kaan Atilla

Production Credits:
Production Company: Motion Theory
Executive Producer: Javier Jimenez

Other Credits:
Editor: Jutta Reichardt
Sound Design: Pete Kneser

147 | 141 ANIMAL

FORMAT: MUSIC VIDEO
ARTIST: R.E.M.
CLIENT: WARNER BROS. RECORDS

Client Credits:
Warner Bros. Video Commissioner: Devin Sarno

Director Credits:
Director: Motion Theory
Director of Photography: Nick Sawyer

Creative/Design Credits:
Creative Directors: Mathew Cullen, Grady Hall
FX Supervisors: John Clark, Tom Bradley
Designers: Jesus De Francisco, Irene Park, Mark Kudsi,
 Shihlin Wu, Mike Slane, Brad Watanabe
3-D Animators: Paulo De Almada, Tom Bradley, John Clark,
 Kirk Shintani, Chris De St. Jeor, Yas Koyama, Linas
 Jodwalis, Tom Bruno

Production Credits:
Production Company: Motion Theory
Executive Producer: Javier Jimenez
Producer: Bo Platt

Other Credits:
Film Effects Insert Cinemetography: Stokes/Kohne Association
Film Effects Supervisor: Dan Kohne
Film Effects DP: Billy Robinson
Editor: Mark Hoffman

M + MOTIVE, INC.

148 | 142 SURROUND SOUND
149 | 143 BASS
150 | 143 SIGNAL PROCESSING

FORMAT: PRODUCT PRESENTATION FILM
CLIENT: BOSE CORPORATION

Client Credits: Buz Laughlin, Jesse Flack

Design/Production Credits:
Company: M, Inc.
Design Director: Joel Markus
Designer: Joel Markus (M, Inc.)
Production (M + Motive)

151 | 145 PASSION MEETS RESEARCH

FORMAT: PRODUCT PRESENTATION FILM
CLIENT: BOSE CORPORATION

Client Credits: Buz Laughlin

Design/Production Credits:
Company: M, Inc.
Design Director: Joel Markus
Designers: Joel Markus (M, Inc.), François Berelowitch
Production: (M + Motive)

152 | 146 BIKE WEEKEND

FORMAT: PROGRAM IDENTITY
CLIENT: DISCOVERY CHANNEL

Client Credits: Jeff Strong, Heather Roymans

Design/Production Credits:
Company: M + Motive
Design Director: Joel Markus
Designers: Joel Markus (M, Inc.), Bob Hoffman (Motive)
Production: M + Motive

153 | 146 WELD OF THE WEEK

FORMAT: PROGRAM IDENTITY
CLIENT: DISCOVERY CHANNEL

Client Credits: Jeff Strong

Design/Production Credits:
Company: M + Motive
Design Director: Joel Markus
Designer: Joel Markus (M, Inc.)
Production: M + Motive

154 | 147 REAL INTELLIGENCE: THE SECRET OF SPYING

FORMAT: PROGRAM IDENTITY
CLIENT: DISCOVERY CHANNEL

Client Credits: Jeff Strong, Keith Jodoin

Design/Production Credits:
Company: M + Motive
Design Director: Joel Markus
Designers: Joel Markus (M, Inc.), Bob Hoffman (Motive)
Production: M + Motive

155 | 148 MONSTER GARAGE

FORMAT: PROGRAM IDENTITY
CLIENT: DISCOVERY CHANNEL

Client Credits: Dan Stanton, Jeff Strong

Design/Production Credits:
Company: M + Motive
Design Director: Joel Markus
Designers: Bob Hoffman (Motive), Joel Markus (M, Inc.)
Production: M + Motive

156 | 149 DISCOVERY GOES TO THE MOVIES

FORMAT: PROGRAM IDENTITY
CLIENT: DISCOVERY CHANNEL

Client Credits: Jeff Strong, Alberto Enriquez

Design/Production Credits:
Company: M + Motive
Design Director: Joel Markus
Designers: Joel Markus (M, Inc.), Bob Hoffmann (Motive)
Production: M + Motive

157 | 150 PLAY LIKE THE PROS

FORMAT: PROGRAM IDENTITY
CLIENT: ESPN

Design/Production Credits:
Company: M, Inc.
Design Director: Joel Markus
Designer: Robert Hoffmann (Motive)
Production: (M + Motive)

158 | 150 NFL ON ESPN

FORMAT: PROGRAM IDENTITY
CLIENT: ESPN INTERNATIONAL

Client Credits: Andy Bronstein , Larry Rosen

Design/Production Credits:
Company: M, Inc.
Design Director: Joel Markus
Designer: Robert Hoffmann (Motive)
Production: (M + Motive)

159 | 150 ESPN SALUTES

FORMAT: PROGRAM IDENTITY
CLIENT: ESPN INTERNATIONAL

Client Credits: Andy Bronstein

Design/Production Credits:
Company: M, Inc.
Design Director: Joel Markus
Designer: Robert Hoffmann (Motive)
Production: (M + Motive)

160 | 151 FÚTBOLDE ITALIA

FORMAT: PROGRAM IDENTITY
CLIENT: ESPN INTERNATIONAL

Client Credits: Andy Bronstein, Gustavo Granados

Design/Production Credits:
Company: M, Inc.
Design Director: Joel Markus
Designers: Joel Markus (M, Inc.), Robert Hoffmann (Motive)
Production: (M + Motive)

APHORISMS USED IN THIS BOOK

All pictorial form begins with the point that sets itself in motion... The point moves ... and the line comes into being—the first dimension. If the line shifts to form a plane, we obtain a two-dimensional element. In the movement from plane to spaces, the clash of planes gives rise to body (three-dimensional)... A summary of the kinetic energies which move the point into a line, the line into a plane, and the plane into a spatial dimension.

Paul Klee, *The Thinking Eye*, 1920s

Style is nothing, but nothing is without style.

Antoine de Rivarol, *Notes, pensées et maximes*, late eighteenth century

Everything in the universe goes by indirection.
There are no straight lines.

Ralph Waldo Emerson, "Works and Days," *Society and Solitude*, 1870

Curiosity is one of the permanent and certain characteristics of a vigorous intellect.

Samuel Johnson, *The Rambler*, 1750–2

Do you wonder that I was late for the theater when I tell you that I saw two Egyptians A's ... walking off arm in arm with the unmistakable swagger of a music-hall comedy team? ... after forty centuries of the necessarily static Alphabet, I saw what its members could do in the fourth dimension of Time, 'flux,' movement.

Beatrice Warde, *Alphabet 1964: International Annual of Letterforms*

The danger of success is that it makes us forget the world's dreadful injustice.
Jules Renard, *Journal*, 1908

Nature, to be commanded, must be obeyed.
Sir Francis Bacon, *Novum Organum*, 1620

We receive three educations, one from our parents, one from our schoolmasters, and one from the world. The third contradicts all that the first two teach us.
Baron Charles de Montesquieu, eighteenth century

My fate cannot be mastered; it can only be collaborated with and thereby, to some extent, directed. Nor am I the captain of my soul; I am only its noisiest passenger.
Aldous Huxley, *Adonis and the Alphabet*, 1956

Unless we see our subject, how shall we know how to place or prize it, in our understanding, our imagination, our affections?
Thomas Carlyle, "Burns," 1828

I and me. I feel me—that makes two objects. Our false philosophy is embodied in the language as a whole: one might say that we can't reason without reasoning wrong.
Georg Christoph Lichtenberg, *Aphorisms*, 1764–1799

BIBLIOGRAPHY

Arnheim, Rudolf. *Film as Art*, California, University of California Press, 1989

Bellantoni, Jeff and Woolman, Matt, *Type in Motion: Innovations in Digital Graphics*, Second Edition, London, Thames & Hudson, 2001

Bringhurst, Robert, *The Elements of Typographic Style, Second Edition*, Vancouver, Hartley & Marks Publishers, 2002

Carter, Rob, *Working with Computer Type 4: Experimental Typography*, Crans, Switzerland, RotoVision SA, 1997

Carter, Rob, *Working with Computer Type 3: Color and Type*, Crans, Switzerland, RotoVision SA, 1997

Cotton, Bob, *Understanding Hypermedia 2000*, Second Edition, London, Phaidon Press, 1997

Culhane, Shamus, *Animation: From Script to Screen*, London, St. Martin's Press, Reprint Edition, 1990

Day, Ben, Carter, Rob, and Meggs, Philip *Typographic Design: Form and Communication*, Third Edition, New York, John Wiley & Sons, 2002

Eisenstein, Sergei, *Film Form: Essays in Film Theory*, Harvest Books, 1969

Eisenstein, Sergei, *The Film Sense*, Harvest Books, 1969

Eisner, Will, *Comics & Sequential Art*, Poorhouse Press, 1994

Fraioli, James O, *Storyboarding 101: A Crash Course in Professional Storyboarding*, Michael Wiese Productions, 2000

Giannetti, Louis, *Understanding Movies*, Ninth Edition, Upper Saddle River, New Jersey, Prentice Hall, 2001

Gotz, Veruschka, *Type for the Internet & Other Digital Media*, Sterling, 2003

Gotz, Veruschka, *Grids for the Internet & Other Digital Media*, Sterling, 2002

Gotz, Veruschka, *Color & Type for the Screen (Digital Media Series)*, New York, Watson-Guptill Publications, 1998

Halas, John, *Film & TV Graphics: An International Survey of Film and Television Graphics*, Zurich, W. Herdeg, Graphis Press, 1967

Hart, John, *The Art of the Storyboard: Storyboarding for Film, TV, and Animation*, Focal Press, 1998

Hawkes, Terence, *Structuralism and Semiotics*, Berkeley, University of California Press, 1977

Herdeg, Walter, editor, *Film & TV Graphics 2: An International Survey of the Art of Film Animation*, Zurich, Graphis Press, 1976

Hiebert, Kenneth J. and Hofmann, Armin, *Graphic Design Sources*, New Haven, Connecticut, Yale University Press, 1998

Hiebert, Kenneth J, *Graphic Design Processes: Universal to Unique*, New York, Van Nostrand Reinhold, 1992

Hofmann, Armin, *Graphic Design Manual: Principles and Practice*, Multilingual Edition, Sulgen, Switzerland, Arthur Niggli Verlag, 2001

Kandinsky, Wassily, *Point and Line to Plane*, New York, Dover Publications, 1979

Katz, Steven D, *Film Directing Shot by Shot: Visualizing from Concept to Screen*, Studio City, California, Michael Wiese Productions, 1991

Kunz, Willi, *Typography: Macro- and Microaesthetics*, Sulgen, Switzerland, Arthur Niggli Verlag, 2004

Landow, George P., *Hyper/Text/Theory*, Second Edition, Baltimore, Maryland, The John Hopkins University Press, 1997

Landow, George P., *Hypertext 2.0: The Convergence of Contemporary Critical Theory and Technology*, Baltimore, Maryland, The John Hopkins University Press, 1994

Laybourne, Kit and Canemaker, John, *The Animation Book: A Complete Guide to Animated Filmmaking—From Flip-Books to Sound Cartoons to 3-D Animation*, Revised Edition, New York, Three Rivers Press, 1998

Maier, Manfred, *Basic Principles of Design: The Foundation Program at the School of Design, Basel, Switzerland*, New York, Van Nostrand Reinhold Company, 1980

Manovich, Lev, *The Language of New Media (Leonardo Books)*, Reprint Edition, Cambridge, Massachusetts, The MIT Press, 2002

McCloud, Scott, *Understanding Comics: The Invisible Art*, Reprint Edition, New York, HarperPerennial and Kitchen Sink Press, 1994

McCluhan, Marshall, Fiore, Quentin, and Agel, Jerome, *The Medium is the Massage*, Reprint Edition, California, Gingko Press, Inc., 2001

McCluhan, Marshall, *Understanding Media: The Extensions of Man*, Reprint Edition, Cambridge, Massachusetts: The MIT Press. 1994.

McLean, Ruari. *The Thames and Hudson Manual of Typography*, Reprint Edition, London, Thames & Hudson, 1992

Mamet, David, *On Directing Film*, Reprint Edition, New York, Penguin Books USA, 1992

Merritt, Douglas, *Graphic Design in Television*, Oxford, Focal Press, 1993

Miller, J. Abbott, *Dimensional Typography: Words in Space (Kiosk Report)*, Kiosk, distributed by Princeton Architectural Press, 1996

Mitchell, William J., *The Reconfigured Eye: Visual Truth in the Post-Photographic Era*, Cambridge, Massachusetts, The MIT Press, 1992

Moholy-Nagy, Laszlo, *Vision in Motion*, Chicago, Paul Theobald and Company, 1965

Monaco, James, *How to Read a Film: The World of Movies, Media, and Multimedia: Language, History, Theory*, Third Edition, New York, Oxford University Press, 2000

Muybridge, Eadweard, *The Human Figure in Motion*, New York, Dover Publications, Inc., 1955

Neuenschwander, Brody, *Letterwork: Creative Letterforms in Graphic Design*, London, Phaidon Press, 1993

Richard, Valliere T. *Norman McClaren, Manipulator of Movement: The National Film Board Years*, An Ontario Film Institute Book, Newark, University of Delaware Press, 1982

Simon, Mark, *Storyboards: Motion in Art*, Second Edition, Focal Press, 2000

Skopec, David, *Digital Layout for the Internet and Other Media*, Crans, Switzerland, AVA Publishing SA, 2003

Spiekerman, Erik and Ginger, E.M., *Stop Stealing Sheep and Find Out How Type Works*, Second Edition, Mountain View, California, Adobe Press, 2002

Tschichold, Jan, *The New Typography: A Handbook for Modern Designers*, Trans. Ruari McLean, Reprint Edition, Berkeley, University of California Press, 1998

Von Arx, Peter, *Film Design: Explaining, Designing with, and Applying the Elementary Phenomena and Dimensions of Film in Design Education at the AGS Basel, Graduate School of Design*, New York, Van Nostrand Reinhold, 1983

Woolman, Matt, *Digital Information Graphics*, New York, Watson-Guptill Publications, 2002

Woolman, Matt, *Sonic Graphics: Seeing Sound*, Rizzoli Publications International, 2000

Woolman, Matt and Bellantoni, Jeff, *Moving Type: Designing for Time and Space*, Crans, Switzerland, RotoVision SA, 2000

Woolman, Matt, *A Type Detective Story, Episode One: The Crime Scene*, Crans, Switzerland, RotoVision SA, 1997

Wong, Wucius, *Principles of Form and Design*, New York, John Wiley & Sons, 1993

Zettl, Herbert, *Sight, Sound, and Motion: Applied Media Aesthetics*, Third Edition, Belmont, California, Wadsworth Publishing Company, 1998

OTHER RESOURCES

American Institute of Graphic Arts (AIGA)
www.aiga.org

Association of Independent Commercial Producers, Inc. (AICP)
www.aicp.com

Broadcast Directors Association (BDA/Promoax)
www.bda.tvwww.promoax.org

Design in Motion
www.designinmotion.com

INDEX